IMAGES
of America

ITALIANS OF
STARK COUNTY

PELOSI'S
TAKE · 'N · BAKE
DELUXE PIZZA

NET WT

1 lb.

Calcium Propionate added to retard spoilage of the Crust.

KEEP
REFRIGERAT

INGREDIENTS OF CRUST: Wheat Flour, Water, Yeast, Salt, Sugar, Baking Soda.

INGREDIENTS OF TOPPING: Tomato Sauce, Pepperoni (Ingredients: Pork, Beef, Salt, Spices, Sugar, Sodium Nitrate) Cheese, Mangoes, Mushrooms, Vegetable and Olive Oil, Flavorings, Salt.

DIRECTIONS
Unwrap and bake 10 minutes in preheated oven at 450 degrees.

U.S.
INSPECTED
AND PASSED B
DEPARTMENT C
AGRICULTUR
EST. 1869

PELOSI'S PIZZA, INC. MASSILLON, OHIO

PELOSI'S TAKE 'N BAKE DELUXE PIZZA, MASSILLON, OHIO. In addition to running an Italian food market in Massillon, Olindo Pelosi also created Pelosi's Take 'N Bake Deluxe Pizza, which he marketed to local grocery stores, including Belloni's IGA in Brewster. (Courtesy of the Olindo and Justina Ventura Pelosi family.)

ON THE COVER: Italians enjoy life to the fullest and love to socialize and have a good time—the more, the merrier. Here, a group of Italians is having an impromptu party on a farm just south of Brewster. This type of gathering was a common way to maintain the community spirit for Italian immigrants. (Courtesy of the John and Celia Paris Mercer family.)

IMAGES
of America

ITALIANS OF
STARK COUNTY

J.A. Musacchia

ARCADIA
PUBLISHING

Published by Arcadia Publishing
Charleston, South Carolina

Printed in the United States of America

Library of Congress Control Number: 2012956150

For all general information, please contact Arcadia Publishing:
Telephone 843-853-2070
Fax 843-853-0044
E-mail sales@arcadiapublishing.com
For customer service and orders:
Toll-Free 1-888-313-2665

Visit us on the Internet at www.arcadiapublishing.com

*In memory of the courage, sacrifice, and spirit
of those who have gone before.*

CONTENTS

ACKNOWLEDGMENTS

This book would not have been possible without the generosity and enthusiastic participation of dozens of people in the current Stark County Italian community. Their amazing photographs and accompanying memories provide a context to the book that can only result from authentic historical moments. In addition to these countless individuals, I also received tremendous assistance from the Stark County District Library Genealogical Division, Stark County Probate Court, the William McKinley Presidential Library and Museum, the Massillon Library, the Sugarcreek Township Historical Society, the Navarre-Bethlehem Township Historical Society, and the Family History Library in Salt Lake City. All contributions are specifically noted in the photograph credits; where no credit is given, the source is from my personal collection. While my goal has always been to accurately document a broad cross-section of the Italian experience, I apologize for any inaccuracies or omissions that may have affected the final edit of this book.

My interest in the subject matter is also very personal and I want to thank my parents, Joseph and Emmy Ream Musacchia, my grandparents Amelia DeAngelis Musacchia and (in memoriam) Bruno Musacchia and Randall and Virginia Ream, and other family members for teaching me the importance of remembering our history and illustrating it to others. I would also like to acknowledge Prof. David Gedalecia, my independent study thesis advisor at the College of Wooster, who taught me about the rewards that researching and writing can bestow on a student and lover of history. My hope is that the readers may find something in the contents of this book that reminds them of their own histories and that they continue to research and pass this knowledge on to others as well. Finally, I would like to thank my personal "support staff," Timothy and Bobo, who have provided me with daily love and companionship in this journey.

INTRODUCTION

The Italian community currently represents the second-largest ethnic group in Stark County. The story behind the people that drove this growth is the subject of this book. The community's emigration from Italy and eventual establishment in Stark County, Ohio, began in the late 1800s. By the early 20th century, Stark County was one of the fastest-growing industrial regions in the nation. To fill the increasing demand for labor, immigrants from primarily Southern Italy settled in the area. Most of them sought economic opportunity; all of them sought a better life for themselves and their families. Like most immigrants, the Italians who came to Stark County possessed a strong work ethic and were willing to sacrifice greatly for a brighter future for themselves, their children, and their grandchildren.

These Italians' unique contributions, sacrifices, and hard work deserve to be honored, remembered, and memorialized. The following chapters give readers an understanding of the lives of the Italian immigrants and an appreciation of their values through their foundations, their faith, their families, and their friends.

One

FOUNDATIONS

Italians came to the United States by ship and made their way to Stark County primarily by train. A number of Italian men came to Stark County alone, worked hard, and saved enough money to eventually send for their families. For some, this process only took a year, while for others it took several years to reunite with their loved ones. During this time, the laying of strong foundations for their new lives became a critical part of the transition from Italian to Italian American. These foundations largely consisted of their workplaces, social clubs, restaurants, and new homes. As with a number of immigrant groups, food also played a critical role in the lives of Italians, representing love, caring, warmth, acceptance, welcome, sharing, and selflessness. It is not surprising, then, that a number of Italian immigrants in Stark County opened Italian restaurants, bakeries, grocery stores, and delis that recalled their Italian neighborhoods back home.

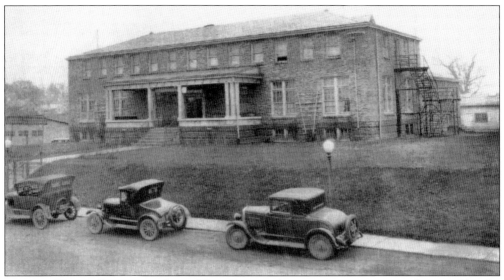

WANDLE HOUSE, BREWSTER, OHIO. This 62-room dormitory was constructed in 1916 by the Wheeling & Lake Erie Railroad with funds contributed by railroaders (including many Italian immigrants) throughout the system. It was first called the Brewster Railroad YMCA but was later known as the Wandle House. It included a fine restaurant, movie theater, and bowling alleys, and was also used as a community center. (Courtesy of the Brewster-Sugar Creek Township Historical Society.)

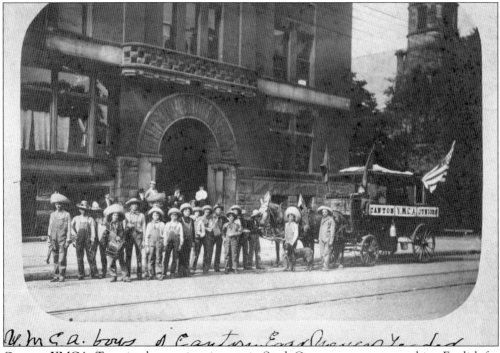

CANTON YMCA. To assist the new immigrants in Stark County, a program teaching English for foreigners was organized in 1905 at the Canton YMCA and was taught by Prof. G.F. Stokey. In addition to two Italians, the first class included four Greeks, six Germans, a Hungarian, and a Romanian. (Courtesy of Canton YMCA.)

10

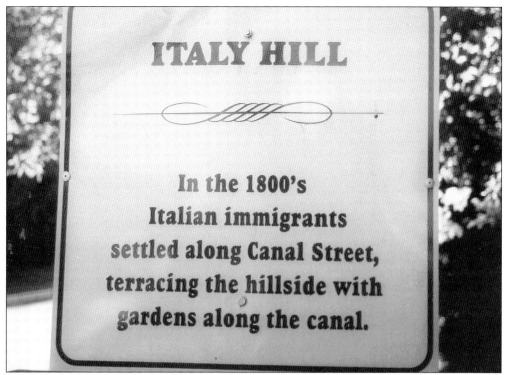

ITALY HILL SIGN, NAVARRE, OHIO. As indicated on this sign located on Canal Street in Navarre, Ohio, in the 1880s, Italian immigrants settled along Canal Street and grew beautiful gardens on the hillside along the canal. The area was known as Italy Hill due to the large number of Italian immigrants who settled there.

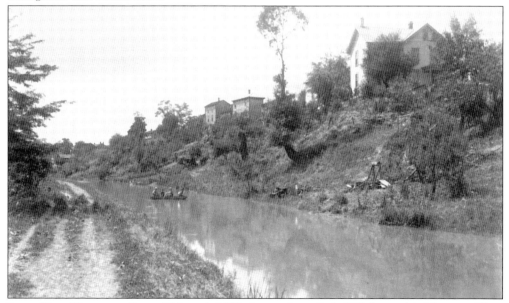

ITALY HILL, NAVARRE, OHIO. This early-1900s image shows Italy Hill, located in Navarre, Ohio. Most Italians who resided on Italy Hill during this time worked in the local coal mines. (Courtesy of Navarre-Bethlehem Township Historical Society.)

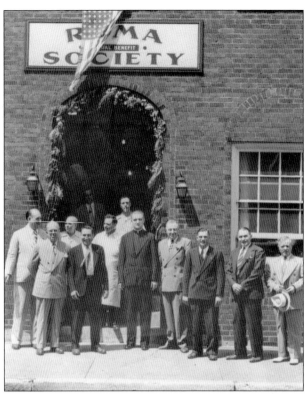

ROMA SOCIETY RIBBON-CUTTING CEREMONY. The Roma Mutual Benefit Society was founded in 1936 to provide both sick and death benefits to those who came to Alliance, Ohio, from Italy. It was also a social club for the Italians of Stark County, offering drinks, dinner, and bocce tournaments to its members. This photograph was taken in 1947 at the dedication of the new building for the society. (Courtesy of Carmella Orsetti Stippich and Carolyn Orsetti Durm.)

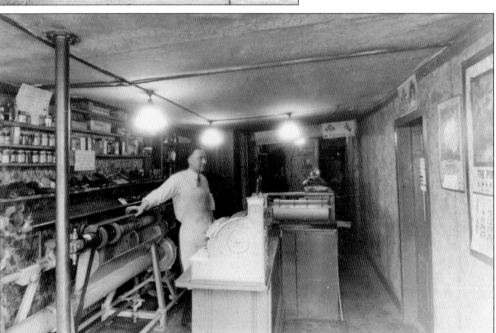

LEONARDO CAMPOLIETO IN COBBLER SHOP. Leonardo Campolieto was born in Greci, Italy, in 1893 and came to the United States in 1910. When he arrived in Canton, he learned a trade: shoe repair. This photograph was taken in Leonardo's first shoe-repair shop in Canton. (Courtesy of William Campolieto.)

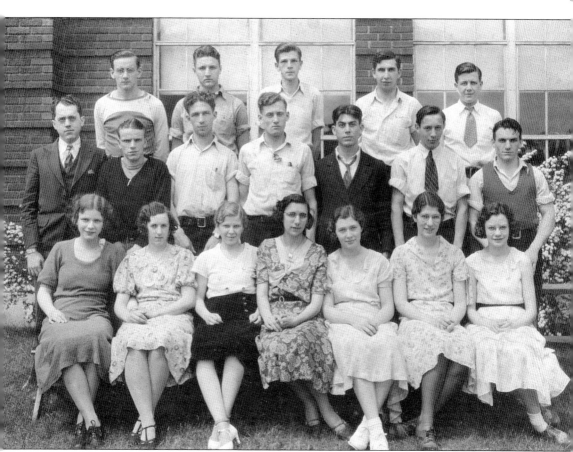

BREWSTER HIGH SCHOOL CLASS OF 1933. In the second row, wearing a tie and a white shirt, is Bunu (later legally changed to Bruno) Bernard Musacchia, a 1933 graduate of Brewster High School. While Bruno was born in Stark County, his parents and older brother were all born in Partanna, Sicily. Also pictured in this photograph are classmates Lloyd Beck, Hermine Rouf, Maurice Glick, Anton Stroh, Richard Lewis, Charles Petscher, Samuel Miller, Clarence Breil, Clarence Davis, Helen Bonstell, Arvilla Powers, Eleanor Schott, Adeline Harrison, Robert Linn, Louis Rozlog, Margaret Meister, and Lois McDowell. The class motto was "With the ropes of the past, we shall ring the bells of the future." (Courtesy of Bruno and Amelia Musacchia family.)

WAYNESBURG, OHIO "BLOCK HOUSE." The Waynesburg, Ohio, "Block House" was owned and built by the coal companies in the early 1900s to provide housing for the immigrants working in the mines. The house at left is still standing. (Courtesy of Christine DiCola.)

ST. BARTHOLOMEW SOCIETY STAND. Between the years 1890 and 1925, the majority of the population of Greci, Italy, decided to leave Europe and travel to the United States. Before too long, immigrants from Greci started to form St. Bartolomeo Societies. St. Bartolomeo was one of the apostles of the Eastern Orthodox Church and was known for traveling to Armenia. The Italians in Greci were originally from Armenia, and they consider St. Bartolomeo the patron saint of their community. One such group was formed at St. Anthony's Catholic Church in Canton. (Courtesy of William Campolieto.)

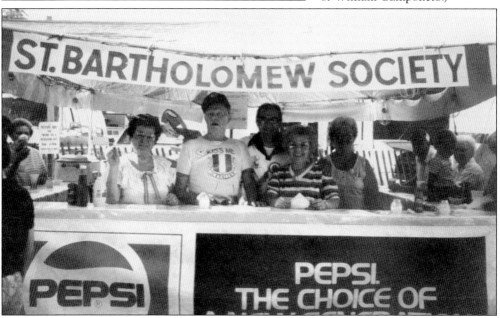

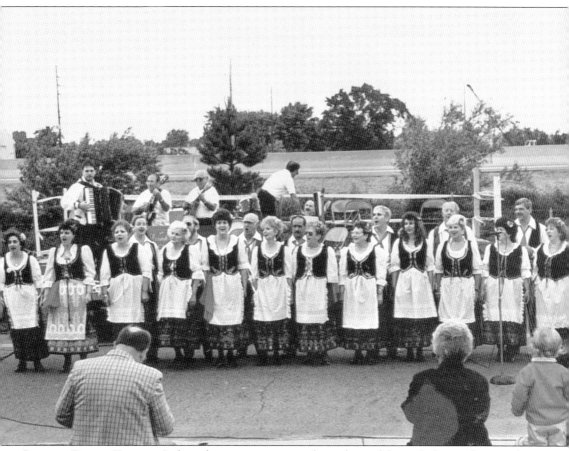

ITALIAN DANCE TROUPE. Italian dance troupes were formed to celebrate Italian culture and traditions. All such troupes wore traditional dress, sang songs in Italian, and danced traditional dances, such as the tarantella. The local Stark County performing troupe, formed in 1975 and incorporated in 1976, was named I Gagliardi Italiani (which translates to "vivacious Italians"). I Gagliardi Italiani performed every year at the Italian American Festival, which was started in 1986 to perpetuate the Italian folk arts. They wore the authentic costumes of the various regions while singing and dancing the regional folklore. (Courtesy of William Campolieto.)

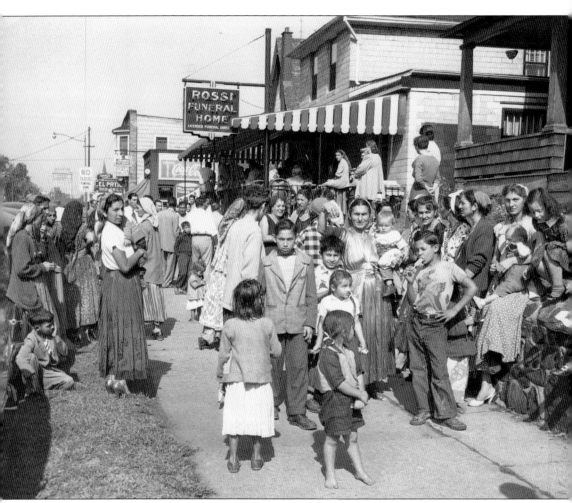

FUNERAL OF THE QUEEN OF THE GYPSIES. In 1951, Annie Mitchell, known as the Queen of the Gypsies, passed away in Aultman Hospital in Canton, Ohio. Her calling hours were held at the Rossi Funeral Home, originally located on East Tuscarawas Street in downtown Canton, and it was reported that 10,000 people came from all over the United States to pay their respects. The Rossi Funeral Home was formed in 1920 by Adam Rossi Sr. and his wife, Rose Romano Rossi, immigrants from Italy. (Courtesy of *Akron Beacon Journal*.)

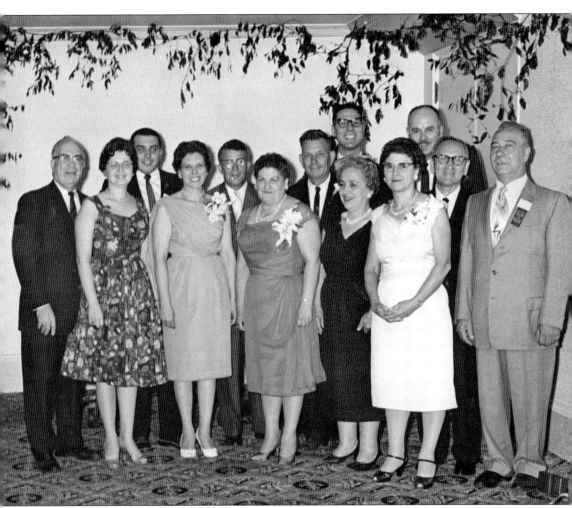

SONS OF ITALY STATE CONVENTION. The Order of the Sons of Italy in America is the largest and oldest Italian American fraternal organization in the nation. In attendance at the July 1961 state convention held in Canton are, from left to right, (front row) Josephine "Josie" Capestrain. Rose DeChellis, Jennie Olivieri, Jackie Sarno, and Rose Capestrain; (back row) Dan Rufo, Pete Carbone, Pat DeChellis, Anthony Olivieri, Bob Capestrain, Tom Fusillo, Ed Sarno, and Sam Capestrain. (Courtesy of Bob Capestrain.)

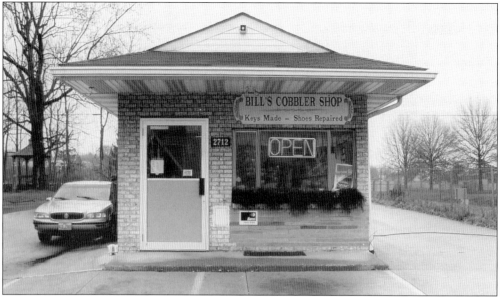

BILL'S COBBLER SHOP. Leonard Campolieto learned the shoe-repair trade in Canton and passed those skills on to his son William. After World War II, William opened his own shoe-repair business, Bill's Cobbler Shop, located at Twenty-seventh Street and Cleveland Avenue in downtown Canton. Bill's Cobbler Shop is still operated by William's son-in-law, John Vellucci. (Courtesy of William Campolieto.)

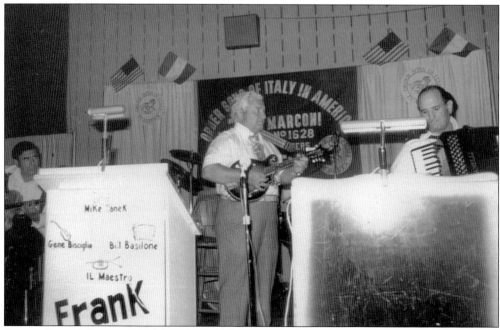

SONS OF ITALY. The mission of the Sons of Italy in America is to serve as the leading organizational voice on the cultural, social, political, and economic issues of importance to Americans of Italian heritage. That cultural heritage includes music, and here, Giuseppe Pileggi and his band perform at a Sons of Italy dinner and dance at the Ben Marconi Lodge in Canton. (Courtesy of Armando and Frances Pileggi.)

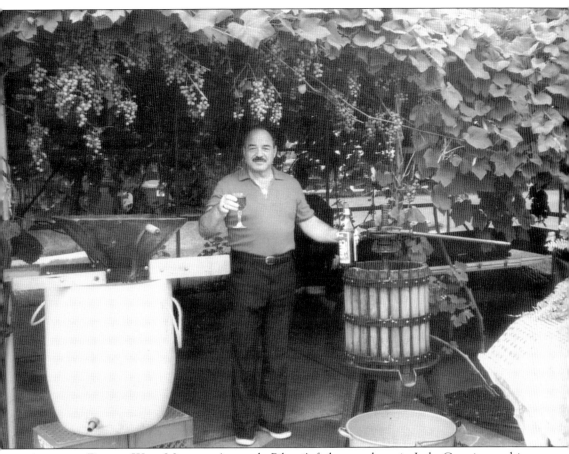

ARMANDO PILEGGI WINE MAKING. Armando Pileggi's father was born in Italy. Carrying on his family's tradition, Armando makes approximately 250 gallons of homemade wine every year. Armando has been invited to some of the most prestigious wineries in the United States and has won 30 medals for his wine. (Courtesy of Armando and Frances Pileggi.)

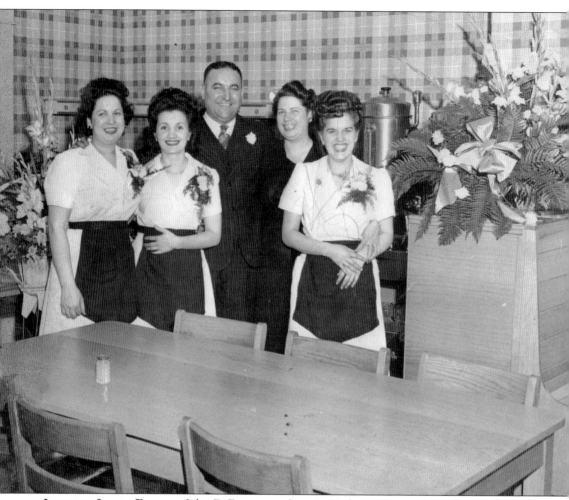

JOHN AND LAURA FERRERO. John D. Ferrero was born in Little California, Pennsylvania, but lived with his aunt Rosa in Northern Italy for 10 years during his youth. In 1920, he came to Massillon, Ohio, and established the Venice Spaghetti House at 1022 Duncan Street. Pictured here are John; his wife, Laura; and several waitresses inside the Venice Spaghetti House. (Courtesy of the John and Laura Ferrero family.)

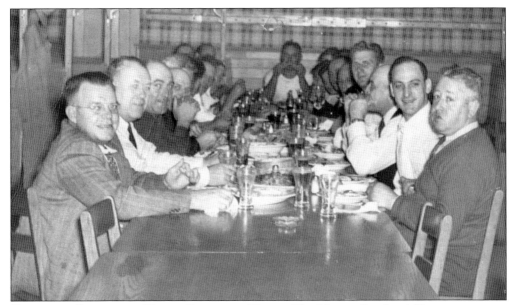

CLEVELAND BROWNS AT VENICE SPAGHETTI HOUSE. The Venice Spaghetti House was a very popular dining establishment in Massillon, and several members of the Cleveland Browns are pictured here, enjoying the delicious Italian food. The spaghetti-and-meatballs dinner cost 50¢, and the steak with mushrooms cost 75¢. By appointment only, one could enjoy a ravioli dinner with chicken for $1. (Courtesy of the John and Laura Ferrero family.)

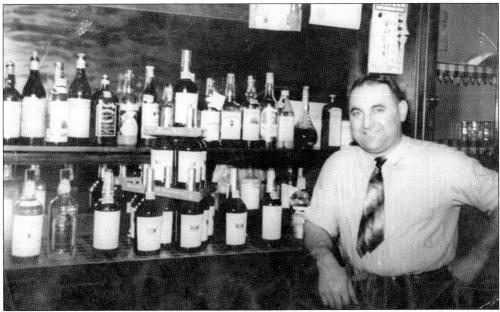

JOHN FERRERO SR. AT VENICE SPAGHETTI HOUSE. When John D. Ferrero and his sister Mary's younger sibling was born, their parents found themselves unable to provide for three children. John and Mary were sent back to Masi, in Northern Italy, to be raised by their father's sister Rosa. When John was about 15 years old, he returned to Ohio. However, every other year, he would return to Italy to visit his "Mama" Rosa, who never married. (Courtesy of the John and Laura Ferrero family.)

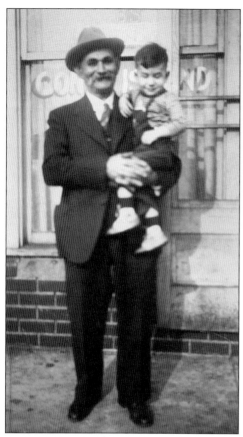

Castenze Musacchia and Grandson Joseph Musacchia. Castenze Musacchia was born in Partanna, Sicily, and came to the United States in 1912 on the immigration vessel SS *Italia*. He worked on the Wheeling & Lake Erie Railroad in Brewster, Ohio, and earned enough money to send for his wife, Ursula, and infant son Matteo in 1913. Here he is pictured with his grandson Joseph Musacchia in front of the Coney Island Café, owned and operated by Joseph's parents, Bruno and Amelia "Millie." (Courtesy of the Bruno and Amelia Musacchia family.)

Marion and Nancy Morris at Belloni's IGA Store. In addition to founding Belloni IGA in 1908 in Brewster, Marion Belloni also built a movie theater and other local businesses. He is pictured here with his granddaughter Nancy Morris in the grocery store. (Courtesy of Marion "Buzz" Belloni.)

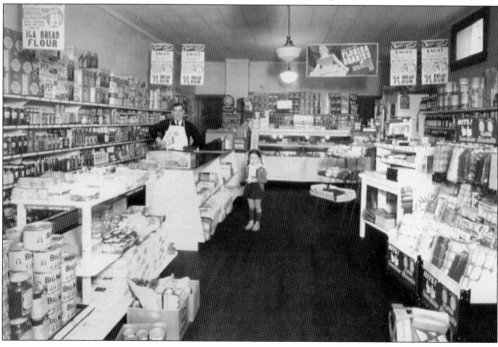

BIAGIO AND ANGELINA DIOGUARDI AT DAUGHTER'S WEDDING. Biagio DioGuardi was born in Greci, Italy, and married Angelina Panella in 1912. He came to the United States in 1913, but before Angelina was able to join him, World War I broke out. She would not be able to travel to join her husband until 1919. (Courtesy of Dorothy and Florence DioGuardi.)

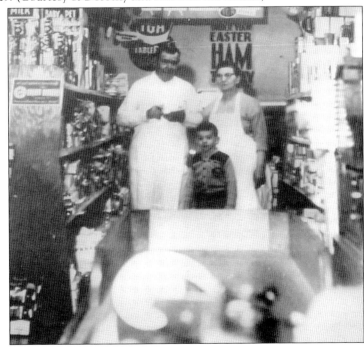

MARION, ANNUNZIATA, AND BUZZ BELLONI. Marion and Annunziata Belloni came to the United States in 1905. They are pictured here in the 1950s with their grandson Marion "Buzz" at the Belloni IGA grocery store in Brewster. Their philosophy could best be summed up in the words of a sign that hung in their store: Food is a Family Affair. (Courtesy of Marion "Buzz" Belloni.)

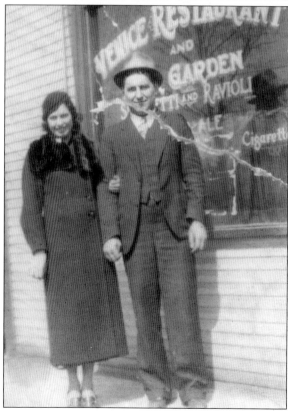

GIUSEPPE PILEGGI IN ITALIAN GROCERY STORE. Giuseppe Pileggi was born in St. Andrea, Calabria, Italy, and one of his great passions was food. He is pictured here in his grocery store, where he sold Italian specialties like salami, olive oil, cheese, zeppole, and cannoli. The Pileggi name has been in the food business for over 75 years, beginning with Giuseppe's father, Vito. (Courtesy of Armando and Frances Pileggi.)

JOHN AND LAURA FERRERO IN FRONT OF VENICE SPAGHETTI HOUSE. John D. Ferrero married Laura Muzi in 1935 in Dennison, Ohio. They had met at the wedding of Michael Porrini and Jeannette DiLoreto. Laura's parents, Andrea and Elvira Muzi, originally from Capitignano, Italy, had 11 children. Andrea Muzi worked on the railroad, and when he retired, the couple moved to Massillon from Dennison. (Courtesy of the John and Laura Ferrero family.)

J.D. Define in Front of Store. In 1916, James "J.D." Define acquired the John Loew property located on Canal Street in Navarre, Ohio. J.D. moved his family into the residence and opened a grocery store. For a few years, he also ran a tavern in the rear of the building. J.D., his wife, May, and their three sons operated a successful family grocery business for over 60 years. In 1977, the Defines' grocery store closed for the last time. (Courtesy of Paula Define Margazano.)

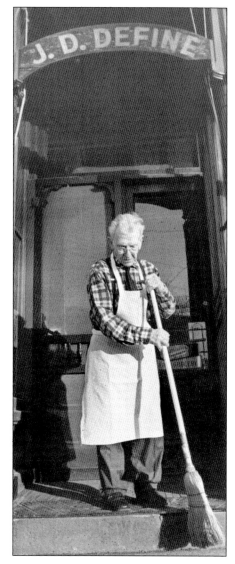

Vincent Define. Vincent Defino and his three brothers have the distinction of being the first Italian immigrants in Stark County. When they arrived from Italy, they settled in Navarre and first started working for the coal mines in that area. They later changed their named to Define. (Courtesy of Paula Define Margazano.)

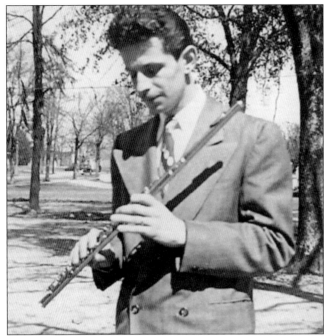

LOUIS MARINI SR. WITH FLUTE. Louis Marini Sr. grew up in Alliance, Ohio, graduated from Mount Union College, and earned his master's degree from VanderCook College of Music in Chicago. He was the band director at Fairless High School in Navarre, Ohio, and composer of the Fairless High School alma mater. He taught at Bowling Green State University for 15 years, where in addition to teaching woodwinds and arranging and conducting the jazz band, he wrote over 180 arrangements for the Bowling Green Falcons marching band. (Courtesy of the Louis Marini Sr. family)

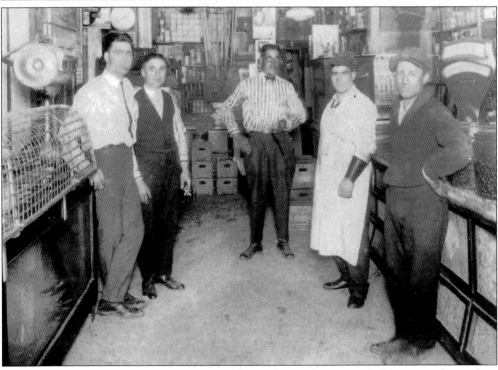

ANGELO FORCHIONE GROCERY STORE. Angelo Forchione Groceries & Meats was located on Madison Avenue in downtown Canton. Pictured in this photograph are, from left to right, Victor Petitte, John Pastore, Leonard Forchione, Fausto Forchione, and Angelo Forchione. Angelo was born in 1896 in Faeto, Italy, and came to the United States in 1913. (Courtesy of the Frank Forchione Sr. family.)

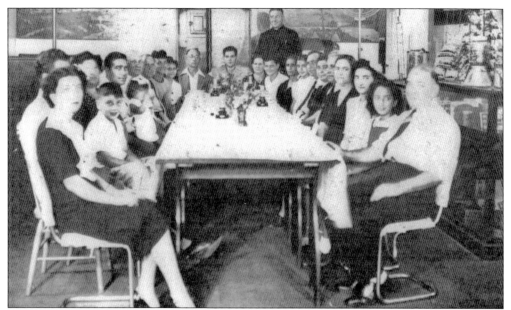

VICTORIA'S CAFÉ IN BREWSTER. Bruno and Maria Codispoti opened Victoria's Café in Brewster in the early 1940s and operated it for 28 years. In this photograph from 1943, they are hosting a gathering in honor of their son Vince Codispoti, who was on leave from the Air Force before leaving for England. Attending the event are Andy Nestico, Katy Nestico, Bruno Nestico, Vicky Nestico, Frank Codispoti, Sam Lijoi, Andyvo Codispoti, Lizzy Codispoti, Bruno Codispoti, Jim Codispoti, Mary Codispoti, Isidore Codispoti, Vittoria Codispoti, Mary Nestico, Andy Papaleo, Rosaria Papaleo, Andy Arena, Victoria Arena, Antoinette Arena, Jean Arena, and Sam Deroma. The gathering was presided over by the Reverend Paul Buchholz, the pastor of St. Therese Catholic Church. (Courtesy of Andy and Leota Codispoti.)

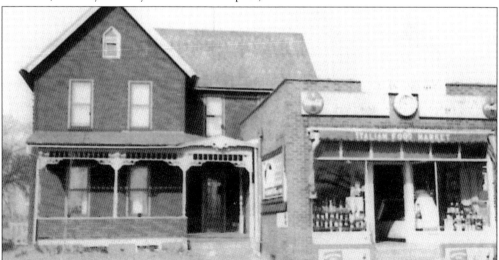

OLINDO PELOSI ITALIAN FOOD MARKET. Olindo and Justina Pelosi opened their Italian food market in the 1950s on Cherry Road in Massillon and lived next door to it with their three children— Nelda, Rinaldo, and Raymond. Olindo was also a serial entrepreneur and was the first business owner to market the concept of a frozen Italian pizza to local grocery stores (see page 1). (Courtesy of the Olindo and Justina Ventura Pelosi family.)

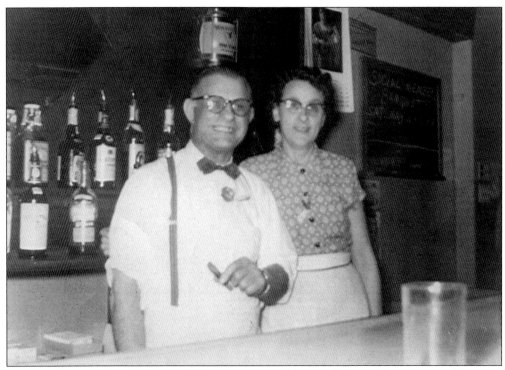

GUS AND ESTHER QUATTORCHI. Gus and his wife, Esther, were two of the original members of the Roma Mutual Benefit Society in Alliance. Here, they are pictured behind the bar at the club. (Courtesy of Carmella Orsetti Stippich and Carolyn Orsetti Durm.)

DIOGUARDI'S STOREFRONT SIGN. Biagio DioGuardi left his native Greci, Italy, in 1913 to join his brother in the grocery business in Canton. He traveled to the United States without his wife, Angelina, and their infant son, Michael. Biagio's older brother decided to return to Italy and sold the store to Biagio in 1919. DioGuardi's Italian Market was originally located at 745 Tenth Street Southeast until 1948, when Biagio moved it to its present location at 3116 Market Avenue North. Angelina worked in the store every day making her spaghetti sauce and was involved in the business until she was 101 years old. (Courtesy of Dorothy and Florence DioGuardi and Marion Mazzarella.)

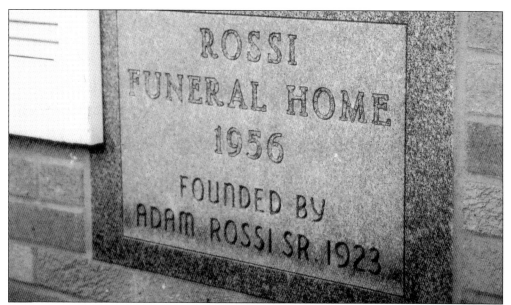

ROSSI FUNERAL HOME SIGN. In 1909, when the six Rossi brothers came to the United States from Avellino, Italy, they decided to go into the funeral business. Dominick Rossi immigrated first and started a funeral home in Utica, New York. Carmen Rossi started one in Akron, while Louis, Fred, and Adam Sr. initially started one in Youngstown. In 1923, Adam Sr. opened his first funeral home in Canton. (Courtesy of Jim Rossi and Bob Forchione.)

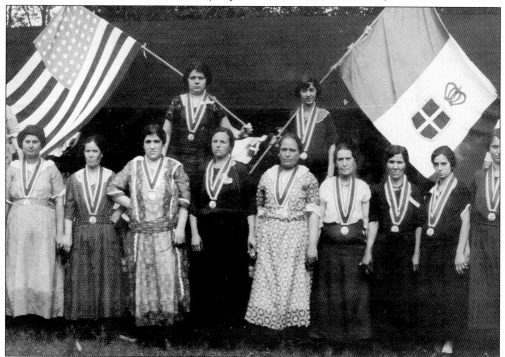

ROMA SOCIETY WOMEN WITH FLAGS. This photograph from the 1930s shows the female members of the Roma Mutual Benefit Society in Alliance. The Roma Mutual Benefit Society was founded in 1936. (Courtesy of Carmella Orsetti Stippich and Carolyn Orsetti Durm.)

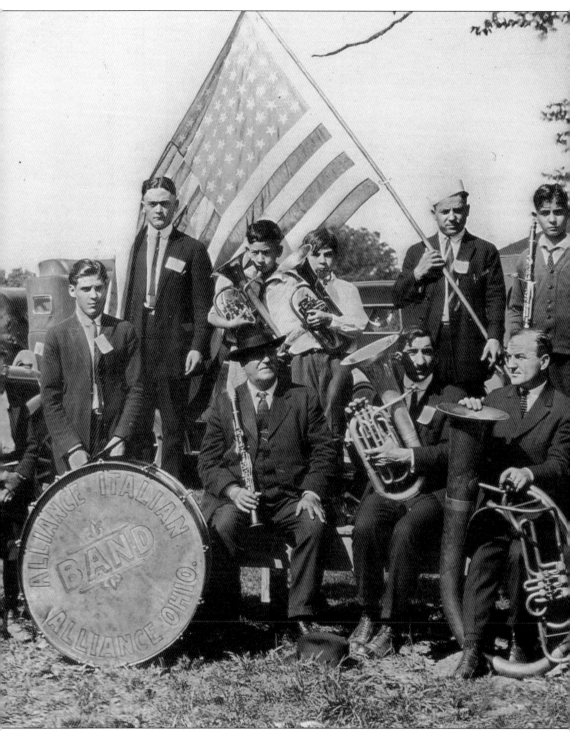

ALLIANCE ITALIAN BAND. Music is an important aspect of an Italian's everyday life. Pictured in this 1924 photograph are members of the Alliance Italian Band. Some of the earliest Italian

families to arrive in Alliance around 1900 were the Alfanis, the Furcalows, and the Andreannis. (Courtesy of Carmella Orsetti Stippich and Carolyn Orsetti Durm.)

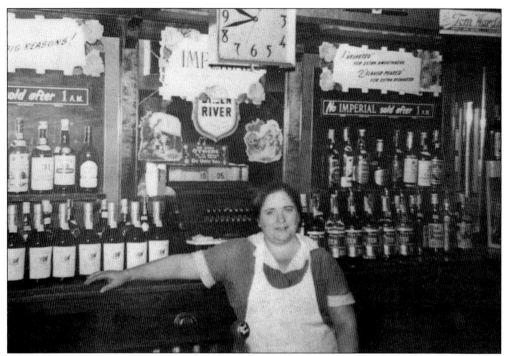

CARMELA CAROZZI AT BELDEN GRILL. Carmela DiLula was born in 1888 and married Dominic Rossi in Italy. Rossi came to the United States with plans to send for his wife as soon as possible, but he unfortunately died in an accident at Republic Steel before he was able to do so. After his death, Carmela married Nick Carozzi, who was born in Montenerodomo, Italy, in 1891. Carmela and Nick raised a son, Frank, in Ohio and founded the Belden Grill in the northeast section of Canton and the family owned and operated the establishment until the late 1980s. (Courtesy of Anna Guidone Carozzi.)

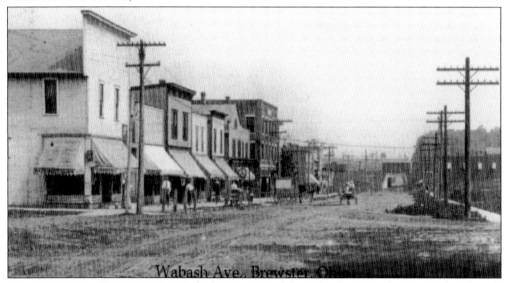

BREWSTER IN THE EARLY 1900s. With the opening of the Wheeling & Lake Erie Railroad yards in Brewster in the early 1900s, the village grew overnight and included a significant number of Italian immigrants. (Courtesy of Sugarcreek Township Historical Society.)

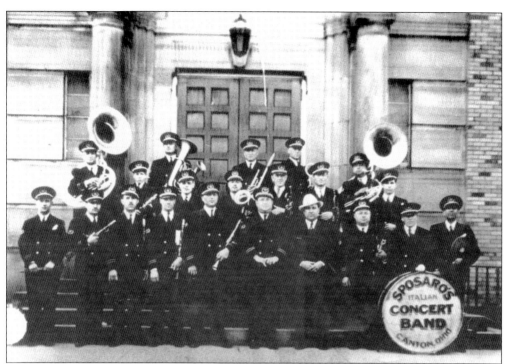

SPOSARO ITALIAN BAND. The Sposaro Italian Band was started in the early 1900s in Canton. Only a few members can be identified in this photograph. In the back, far right is tuba player Samuel Balsam. Samuel was born in 1895 in Italy and came to the United States in 1910. He was a driver and lived on Liberty Street in Canton. To the left of Sam is trumpet player Dan "Red" DiMarzio, who was born in 1901 and lived on Liberty Street. Standing in the first row, wearing the white fedora, is Louie Marino, who was born in 1903. (Courtesy of Armando Pileggi and Dan Marino.)

ANNA GUIDONE WITH HER BROTHER SAM. Anna Guidone is pictured here with her younger brother Sam in front of their family's restaurant/bar in Wellsville. Anna and Sam are two of the 11 children of Sabatino "Sam" and Esther Guidone. In 1946, the family moved to Canton. (Courtesy of Anna Guidone Carozzi.)

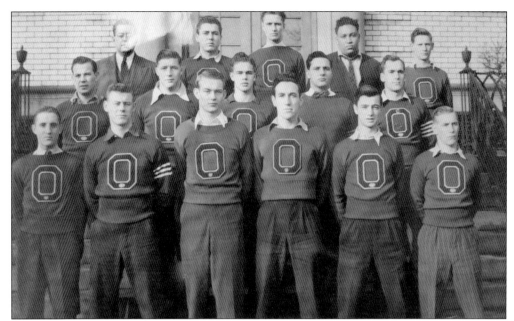

ORRVILLE HIGH SCHOOL CLASS PHOTOGRAPH. Matthew Chatterelli (first row, second from right) is pictured with the "O" Club of Orrville High School. The "O" Club was an athletic organization, and membership was by invitation only. Chatterelli was the starting quarterback for the football team, and also played basketball and baseball for Orrville. He graduated in 1941. (Courtesy of Matthew and Caroline Chatterelli.)

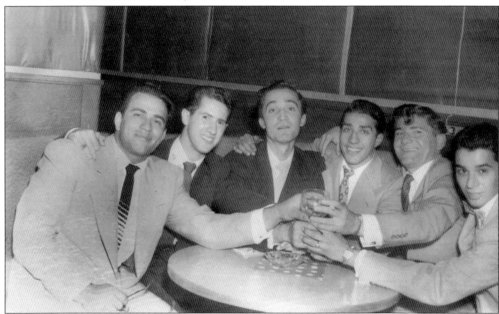

OHIO STATE UNIVERSITY ITALIAN FRATERNITY. Frank Carozzi attended Ohio State University and, while there, joined the Italian fraternity. Here, he is pictured in 1953 with his fellow brothers at the Frolics Club Bar Lounge, the Fun Spot of Columbus, located on High Street in downtown Columbus. Pictured, from left to right, are C. Fatica, F. Frank, R. Longo, F. Sinacolo, Carozzi, and R. DiRosario. (Courtesy of Anna Guidone Carozzi.)

ANNA GUIDONE AT ST. PETER'S. Anna Guidone is pictured here with her friend Joyce Dedell. The girls were in the eighth grade at St. Peter's Catholic School in Canton when this photograph was taken. (Courtesy of Anna Guidone Carozzi.)

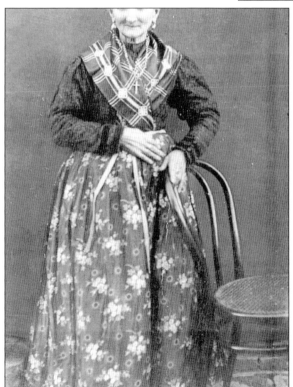

TOMASINA BASTARDO. Tomasina Grima was born in Vieste, Italy, and married Matteo Bastardo. Their daughter Lucia, also born in Vieste, came to the United States alone with her two young children. Here, Tomasina is seen in her traditional Italian dress. (Courtesy of Matthew and Caroline Chatterelli.)

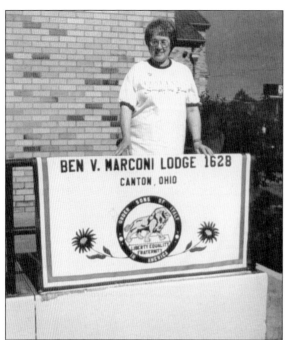

MARION MAZZARELLA. The Sons of Italy Ben V. Marconi Lodge No. 1628 was chartered in April 1916. The lodge first allowed female members in 1962. Having already held several offices with the Sons of Italy in prior years, Marion Mazzarella made history in 1998 by being named the first female president of the lodge. Here, Marion is pictured with the Ben V. Marconi Lodge banner at a lodge event. (Courtesy of Marion Mazzarella.)

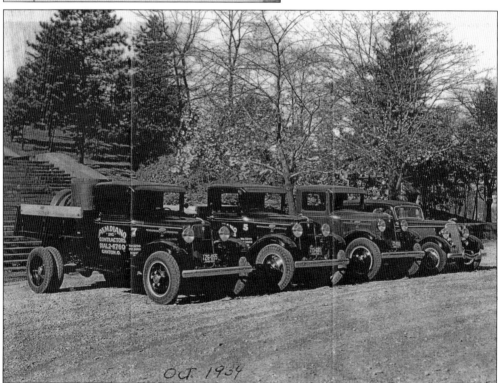

A&M DIANO TRUCKS, CANTON, OHIO. Emidio (aka Midio) Diano and his son, Anthony, operated a general contracting business in Canton called A&M Diano Construction. Pictured here in 1934 are the business's company trucks. In the background is the William McKinley Monument. (Courtesy of Darlene Diano Guynup.)

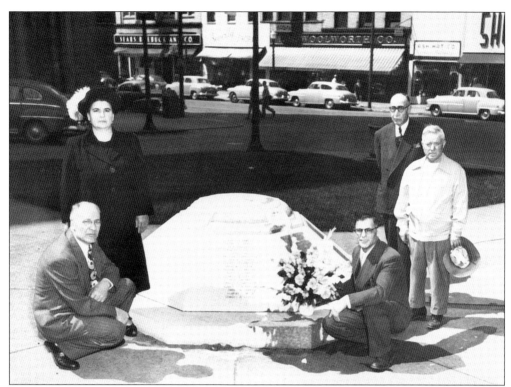

ROMA SOCIETY MONUMENT PHOTOGRAPH. In the early 1900s, there were a number of Italian Mutual Benefit Societies. Most of the clubs were formed to aid Italians in need. By the late 1970s, active Italian clubs included the Amerital Benefit Association, the American-Italian Women's Club, Dante Alighieri, Holy Name Society, Order Italian Sons and Daughters of America (ISDA) 194, the Northern Italian Club, St. Andrea Ionio, the St. Bartolomeo Society, Sons of Italy Lodge No. 1628, the Unique Club, United Fossa Talese Club, and the Roma Society (pictured). (Courtesy of Carmella Orsetti Stippich and Carolyn Orsetti Durm.)

GEORGE CODIANO CITIZENSHIP. All Italian immigrants worked very hard and were extremely proud to become American citizens, and George Codiano was no exception. Born in Foggia, Italy, in 1900, he is pictured here in his official citizenship photograph. In 1923, George married Minnie Tozzi, also born in Foggia, at Firestone Park First Presbyterian Church in Akron. George came to the United States in 1911; Minnie, in 1912. In 1974, Minnie and George traveled back to Foggia (where they had been next-door neighbors) for the first time since leaving as children. (Courtesy of Matthew and Caroline Chatterelli.)

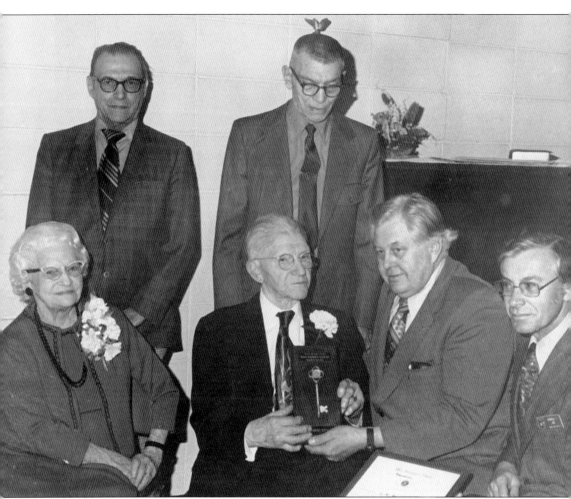

J.D. DEFINE KEY TO CITY. One of the most beloved citizens of the village of Navarre was J.D. Define, who was born in Italy and operated his grocery store in Navarre for 60 years. Here, J.D. and his wife, May, are being presented with a key to the village in honor of their contributions to the community. (Courtesy of Paula Define Margazano.)

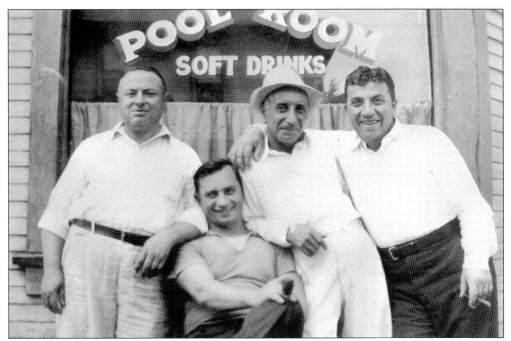

WILLIAM CAMPOLIETO POOL ROOM. In this photograph, William Campolieto (second from left) is posing with his friends in front of one of downtown Canton's local hangouts, the Pool Room. (Courtesy of William Campolieto.)

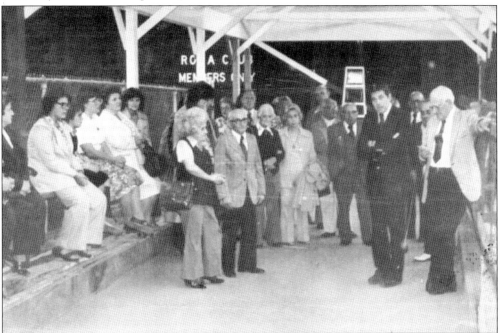

BOCCE BALL AT ROMA SOCIETY. Some of the benefits that the Roma Mutual Benefit Society provided were social in nature. Here, members are seen competing in a regular bocce ball tournament. The bocce ball court is attached to the Roma Mutual Benefit Society's building in Alliance. (Courtesy of Carmella Orsetti Stippich and Carolyn Orsetti Durm.)

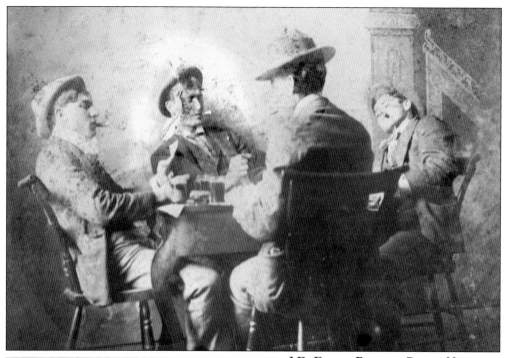

Contractor's hobby!
See page 6

Driving Champion tests new '53 trucks! See page 4

J.D. DEFINE PLAYING CARDS. Here, J.D. Define (far left) is seen enjoying a cigar and playing some type of card game with, clockwise, John Dredtke, Bob Adley, and William Willifer. (Courtesy of Paula Define Margazano.)

CLUES MAGAZINE FEATURING ANTHONY DIANO. Anthony Diano started earning his living with a wheelbarrow, pick, shovel, and rake. He became a successful businessman in concrete, sand, gravel, and cement. However, his hobby was his love of animals. Diano's Palomino Farm, in Canton, eventually grew to include animals from Africa and Asia. He also owned a circus for a short time. In 1937, Anthony married Catherine Cappocia at St. Anthony's Catholic Church. She was the daughter of Angelo and Victoria Tizzeti Capoccia, both born in Italy. Anthony enjoyed celebrating his namesake feast day—at St. Anthony's, where he would supply "blessed bread" and an Italian band along with elephants to lead the parade of the St. Anthony statue through the neighborhood streets. (Courtesy of Darlene Diano Guynup.)

Two

FAITH

Not all, but the vast majority of Italians are Roman Catholic. Accordingly, Catholic Mass played an important role in the life of the newly established community of Italian immigrants in Stark County. Receiving the sacraments was a time for celebration. Baptisms, First Holy Communions, confirmations, and weddings were opportunities to celebrate life, faith, and family. It was not unusual for these events to be attended by extended family and friends and would be unthinkable without traditional *bomboniere*, a type of elaborate party favor. Sugar-covered almonds (*confetti*) signifying prosperity and fertility have traditionally been given to guests as a memento of the blessed event. In the city of Canton, most Italian immigrants began attending Mass at St. Peter's Church, located downtown between Cleveland and Market Avenues. However, the Catholics of Italian extraction in the parish of St. Peter's felt a definite need to have services conducted in their native tongue, and the Most Reverend Ignatius F. Horstmann assigned an Italian priest, Fr. Adolfo Cascianelli, the task of organizing a parish for this purpose. The parish was named St. Anthony's, and for a year its services were held in St. Peter's Church. In 1908, the parish was formally organized, and Father Cascianelli was appointed as the first pastor. The congregation purchased a lot on Liberty Avenue, and its first church was fully completed in October 1908. This building was used until 1927, when the present church structure was completed and dedicated. The old building has since been razed, but the lot on which it stood is still the property of the parish.

The village of Brewster was founded in the southwestern part of the county in 1906, when the Wheeling & Lake Erie Railroad located its shops and offices in the town. With the shops and offices came Catholics from many states and of several national origins, with Italians, Croatians, and Slovenians predominating. These Catholics attended services at St. Clement in Navarre and at St. Joseph and St. Mary, both in Massillon. In 1927, at the request of about 80 families, the Most Reverend Joseph Schrembs, Bishop of Cleveland, established St. Therese Parish, with Fr. Thaddeus Marchant as its first pastor. The first Mass in Brewster was offered on December 4, 1927. Sunday Masses were said in the round for the next six months. On April 15, 1928, the Right Reverend Monsignor Clement H. Treiber officiated at the ground-breaking ceremony for the church. Three months later, the structure was entirely completed. The plain church, of concrete and wood construction, was dedicated by Archbishop Schrembs on September 16, 1928. At this time, it was placed under the protection of St. Therese, the Little Flower of Jesus.

Stark County became the home of several more Italian churches during this time, including notable parishes such as St. James Catholic Church in Waynesburg, located in the southeast section of the county. St. James was organized in 1927 largely due to the influx of Italians. The Italians in surrounding Waynesburg primarily worked at Waynesburg Brick & Clay, which was organized in 1889.

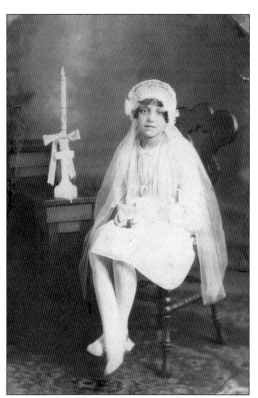

DONATA CIPRIANI FIRST COMMUNION.
Donata Cipriani was born in Pettorano
sul Gizio, Italy, in 1897 and made her
First Holy Communion at St. Clement
Church in Navarre. (Courtesy of the
John and Celia Paris Mercer family.)

**MARY PRESUTTI AND RINALDO
ANGELANTONI WEDDING.** Mary Presutti
married Rinaldo Angelantoni in November
1936 in Canton. Rinaldo was born in Italy
to Prospero and Joan Angelantoni, and
Mary was born in Canton to Dominick
and Anna Presutti. The couple resided in
Canton, where they owned a restaurant
and raised two daughters, Jean Ann and
Anna. Pictured are, from left to right, Fred
Capaldi, Susie Paolucci, Rinaldo, Mary,
Louis Viti, and Carmel Mancini (Courtesy
of Jean Ann Angelantoni Campanelli.)

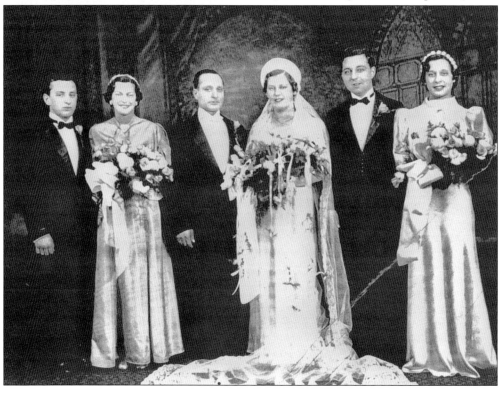

Paris/Mercer Wedding. Celia Paris married John Mercer in 1944 at St. Therese Catholic Church. The maid of honor was the bride's sister, Mary, and the best man was Anthony Medure from Brewster. (Courtesy of the John and Celia Paris Mercer family.)

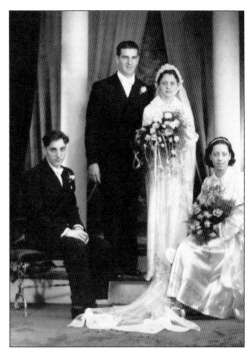

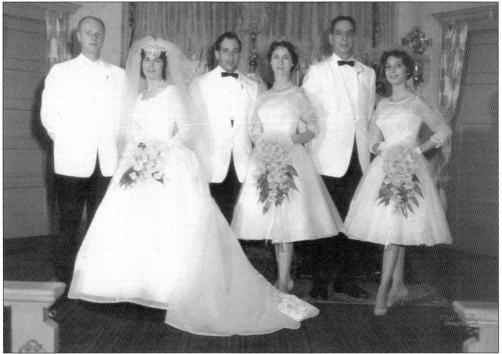

Maria Nunziata Cavicchia and Arthur Larson Wedding. Maria Nunziata Cavicchia married Arthur Larson in August 1961 at St. Therese Catholic Church in Brewster. Arthur was from Youngstown, and Maria was born and raised in Brewster. Also pictured are, from left to right, Maria's brothers Romano and Dominic, serving as groomsmen, and Antoinette DeAngelis and Flora Mazzaferri, serving as bridesmaids. (Courtesy of Maria "Mary" Larson.)

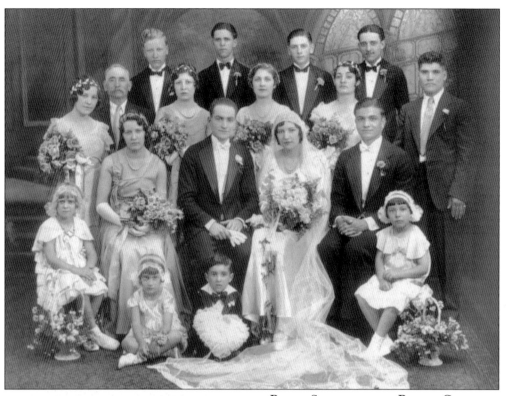

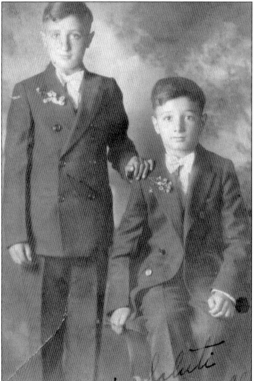

ROCCO SCHIAVONE AND PERLINI COLETTI WEDDING. Perlini "Pearl" Coletti was born in Italy in 1913 and came to the United States in 1919 with her mother, Mary. Perlini married Rocco Schiavone in June 1931 at St. Anthony's Catholic Church. Rocco was born in Castelluccio, Italy, in 1909 to Joseph and Anna Ziccardo Schiavone and came to the United States in 1916. Rocco was a member of the St. Andrea Society, an Italian mutual benefit society. (Courtesy of Sam Coletti.)

ANGELO AND MATTHEW CHATTERELLI FIRST COMMUNION. Brothers Angelo (left) and Matthew Chatterelli were born in Orrville and made their First Holy Communion at St. Agnes Catholic Church. As adults, both moved to Stark County to work on the railroad. Both served in the US Army during World War II and were part of the invasion at Utah Beach in Normandy, France. Angelo, in the infantry, landed first. Matthew, in the ammunitions unit, arrived soon after. (Courtesy of Matthew and Caroline Chatterelli.)

ARMANDO PILEGGI AND FRANCES CODISPOTI WEDDING. Frances Codispoti married Armando Pileggi in July 1959 at St. John's Catholic Church in Canton. Frances was born in Naples, Italy, and came to the United States in 1958. Armando was born in the United States. (Courtesy of Armando and Frances Pileggi.)

JEANNETTE DILORETO AND MICHAEL PORRINI WEDDING. In October 1933, Jeannette DiLoreto married Michael Porrini at St. Therese Catholic Church in Brewster. Angela Rivelli of Wellsville was the maid of honor, and James Porrini served his brother as best man. Bridesmaids were Jennie Frailly, Amelia DeAngelis, Benedetta Musacchia, Celia Paris, and Mary Nardi of Dennison. Ushers included Joe Maritobo, Nick Broglio, William Hustler, Alto Farrano, and Peo DiLoreto. Michael was a member of the Massillon Merchants football team and worked for Massillon Steel Casting & Co., and he and Jeannette raised two daughters, Marjorie and Lauretta. (Courtesy of Lauretta Porrini Gerber.)

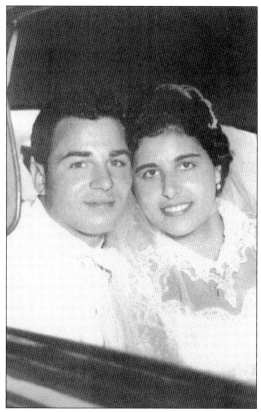

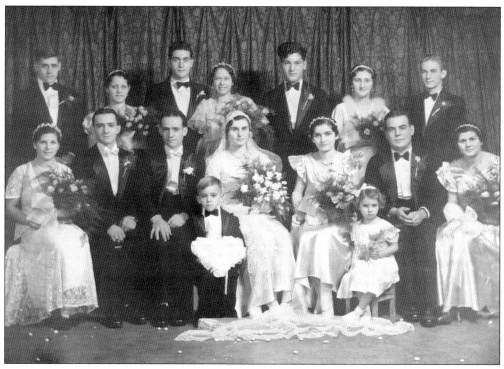

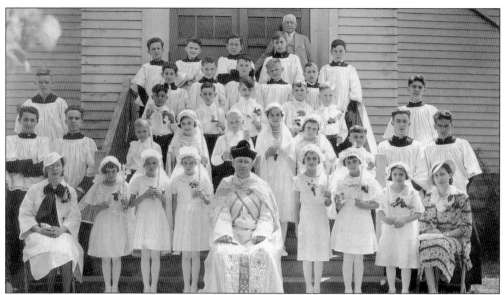

St. Therese First Communion Class with Bishop. Pictured is a First Holy Communion class with the bishop. The only individuals identified are (front row) Gina DeAngelis (second from right) and teacher Louise Belloni Morris (far right). (Courtesy of Greg and Sue Monsanty.)

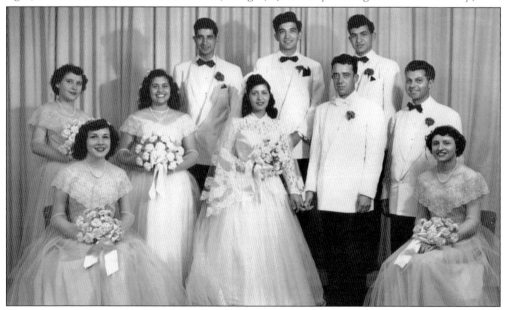

Lorenzo Scassa and Louisa Manello Wedding. Louisa Manello married Lorenzo Scassa in July 1951 at St. Therese Catholic Church. In the bridal party were Esterina Manello (cousin of the bride), Gina DeAngelis, Silvio Manello (twin brother of the bride), Mazz Manello (cousin of the bride) and best man Dominic Schilag. Louisa was born in 1928 in St. Andrea, Calabria, Italy. When she was two years old, her mother, Louise Nestico, passed away. Shortly after her mother's death, her father, Andrew Manello, came to the United States, and Louisa was raised by her grandmothers in Italy. When she was 12 years old, Louisa joined her father. Lorenzo was born in Abruzzi, Italy, and was a prisoner of war for four years in Italy. He came to the United States in 1947 and worked at Republic Steel. (Courtesy of Louisa Manello Scassa.)

MARY VARASSI AND JAMES GALLO WEDDING. Mary Varassi married Gennato "James" Gallo in Wooster, Ohio. Mary had come by herself to the United States to get married, and James, who had immigrated in 1919, worked in the local brick factory. The couple had six children—three were born in Wooster, and three were born in Navarre. (Courtesy of Robert Gallo.)

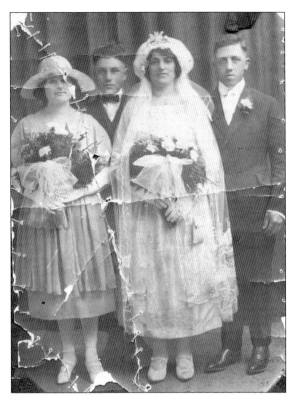

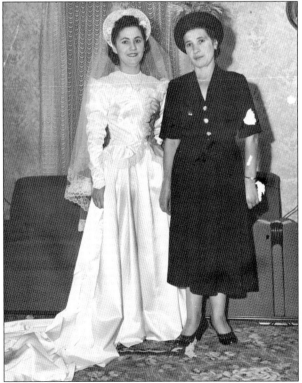

VIRGINIA AMMANNITI AND MOTHER. Virginia Ammanniti married Paul Define in November 1949 at St. Therese Catholic Church. She is pictured here with her mother, Argia Palidori Ammanniti. Argia was born in Capitignano, Italy, and was raised by nuns in an Italian convent after her mother died when she was an infant. Argia and her husband, Giulio, came to the United States in 1927. (Courtesy of Paula Define Margazano.)

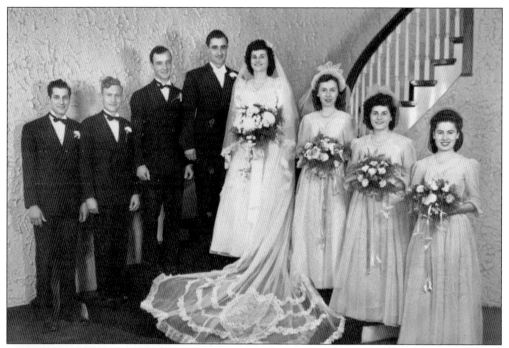

JOSEPHINE MUSACCHIA AND ANGELO CHATTERELLI WEDDING. Josephine Musacchia and Angelo Chatterelli were married in September 1946 at St. Therese Catholic Church. Angelo was born in Orrville in 1920 to Joseph and Lucia Bastardo Chatterelli and lived most of his life in Brewster. He retired in 1978 from the former Norfolk & Western Railroad and was the leader of the Ange Chatterelli Orchestra, known for its big-band music and the last band to play in the ballroom of the former Meyers Lake in Canton. Josephine also retired from the Norfolk & Western Railroad. The couple had one son, Joseph Chatterelli.

BEN DICOLA AND ARTHUR DONATINI, KNIGHTS OF COLUMBUS. Ben J. DiCola (left) and his good friend Arthur Donatini are pictured in their Knights of Columbus regalia at St. Anthony's Catholic Church. Ben's parents, Giacomo and Elisabetta Trilli DiCola, were born in Roccarozzi, Italy, and came to the United States in 1904 with their infant daughter, Giovanna, settling in East Palestine. Unfortunately, Giovanna contracted meningitis and passed away in 1905. (Courtesy of Christine DiCola.)

AMELIA DEANGELIS FIRST COMMUNION.
Amelia DeAngelis made her First Holy
Communion at St. Therese Catholic
Church in Brewster. Her mother, Maria,
passed away when Amelia was only
one and a half years old, and her father,
wanting to ensure that she would be
well cared for, left her in the care of
temporary foster parents Peter and Merle
Larson. (Courtesy of the Bruno and
Amelia DeAngelis Musacchia family.)

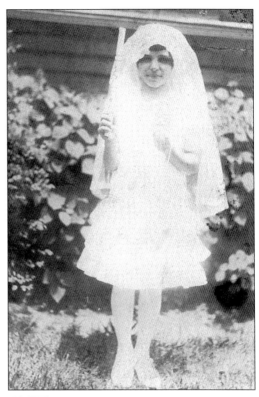

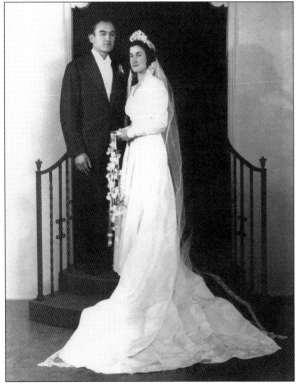

BEN AND VERN DICOLA WEDDING.
Vincenza "Vern" Panella was born
in Ohio to Leonardo and Louisa
Panella. She had one brother,
Michael, and one sister, Esther
Panella Capp. Vern married Ben
J. DiCola in 1940 in Canton at
St. Anthony's Catholic Church.
(Courtesy of Christine DiCola.)

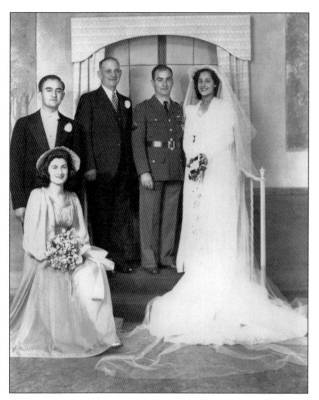

MICHAEL AND ANNE PANELLA WEDDING. Anna Bernabei married Michael Panella in September 1942 at St. Anthony's Catholic Church. Anna was one of nine children born to Giacomo and Catherine Julian Bernabei. Her father, Giacomo, was born in Italy in 1877 and came to the United States in 1901. Catherine was born in Italy in 1890 and came to the United States in 1903. Anna's siblings were Joseph (born in Italy), Robert, Elizabeth, Anthony, Helen, Alveda, Carmella, and Vincent. The groom, Michael, was the son of Leonardo and Louisa Semonella Panella. The couple is pictured here with the groom's sister Vincenza; her husband, Ben; and father of the bride, Giacomo Bernabei. (Courtesy of Christine DiCola.)

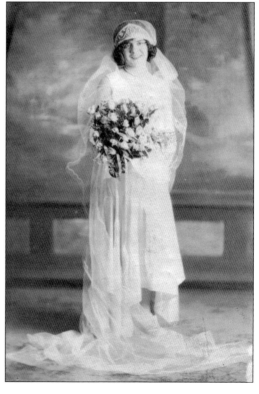

MARY DiCOLA BRIDE. Mary DiCola, born in 1910 in Ohio to James and Elisabetta Trilli DiCola, married Raffaele Cozzoli in 1930. Raffaele was born in Waynesburg in 1907 to Amdeo and Severina Puccetti Cozzoli and worked in the local brickyard. By 1940, Mary and Raffaele had three children—Dorothy, Anna, and Raffaele Jr. (Courtesy of Christine DiCola.)

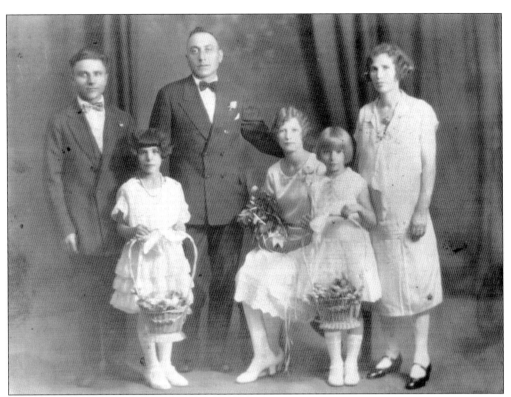

STUCCO AND EUNICE WEDDING. Amelia DeAngelis (far left) was the flower girl in the wedding of Stucco and Eunice (last name unknown) at St. Therese Catholic Church in Brewster in the early 1920s. (Courtesy of the Bruno and Amelia Musacchia family.)

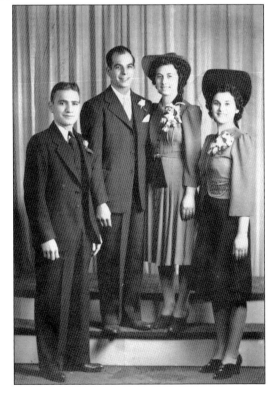

MARIANO DEANGELIS AND ANNA MANACK WEDDING. Anna Manack married Mariano DeAngelis in October 1940 at St. Therese Catholic Church. Mariano was born in Amatrice, Italy, in 1913 and came to the United States with his mother and two sisters in 1915. He served his adopted country in the US Army during World War II. Anna's parents, Felix and Josephine, were born in Vastogirardi, Italy, and came to the United States in 1885. Felix worked in the coal mines, and he and Josephine lived in Navarre.

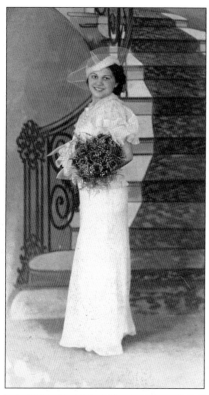

BENEDETTA MUSACCHIA WEDDING DAY. Benedetta Musacchia married Leonard Orlando at St. Therese Catholic Church. Benedetta was born in Brewster in 1918, and Leonard was born in Canton in 1911. In 1940, the couple lived in Canton, and Leonard worked for a file cabinet company. His parents, Anthony and Rose, were both born in Italy and came to the United States in 1906.

GIOVACCHINO CAVICCHIA (CAVESLIO) AND FERMINIA DEANGELIS WEDDING PARTY. Giovacchino "Jack" Cavicchia and Ferminia "Fern" DeAngelis were married at St. Therese Church in Brewster, Ohio, on June 21, 1924, when Fern was only 16 years old. Pictured here are, from left to right, (first row) Joseph Wilyat, unidentified, Fern, Jack, Amelia DeAngelis (sister of the bride), and Mary Wilyat; (second row) unidentified, Antonio DeAngelis (father of the bride), and Julio Fulvimari (from Akron, Ohio). Julio was born in Italy in 1898 and came to the United States in 1910. Jack was born May 5, 1896, in Collenoveri, Italy, and came to the United States in 1912 from Capitignano, Italy. Fern was born in 1909 in Amatrice, Italy, and came to the United States in 1915 on the immigration vessel SS *Patria*.

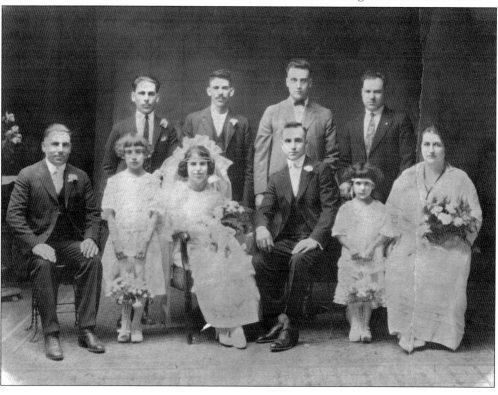

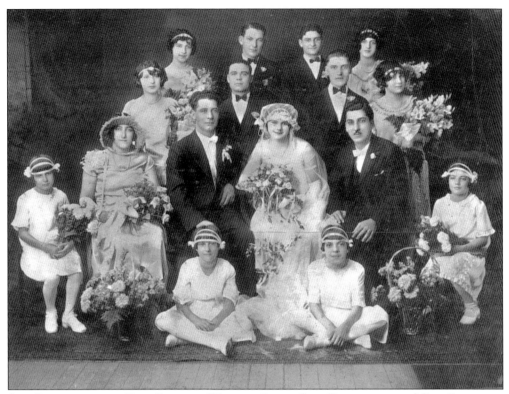

SAM CAPESTRAIN AND ROSE RAMUNO WEDDING PARTY. Rose Ramuno married Sam Capestrain in September 1927. The ceremony was held at St. Mary's Catholic Church in Canton because St. Anthony's was under construction at the time. The members of the wedding party, from left to right, are (first row) Virginia Marcanthony and Julia Ramuno; (second row) Ann Marcanthony, Nicolette Bucci, Sam Capestrain, Rose Romano, Tony Bucci, and Rose DeGasperis; (third row) Antonette Tucci, Arthur Capestrain, Carl Ramuno, Ann Santora; (fourth row) Lillian Gaetano, Alphonso Giacomo, Michael Valentine and Millie Valentine. (Courtesy of Bob Capestrain.)

WILLIAM CAMPOLIETO AND YOLANDA VARN WEDDING PARTY. Yolanda Varn married William Campolieto in May 1947 at St. Anthony's Catholic Church. William, who was born in 1916 in Canton to Leonardo and Angeline Orlando Campolieto, owned and operated a shoe-repair shop. Yolanda was born in 1919 in Canton to Dominick and Nicoletta Scarone Varn. (Courtesy of William Campolieto.)

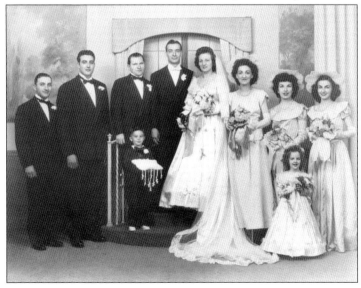

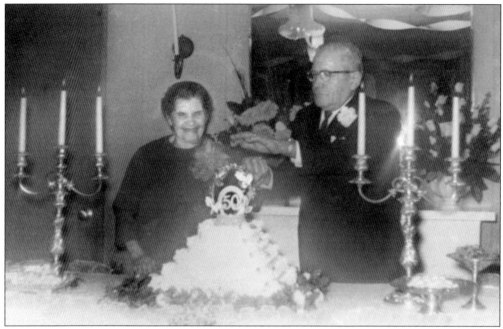

ADAM ROSSI AND ROSE ROMANO 50TH WEDDING ANNIVERSARY. Adam Sr. and Rose Romano Rossi celebrated their 50th wedding anniversary in February 1966. Both were born in Avellino, Italy. Adam immigrated to the United States with his six brothers and, upon arrival, decided to enter into the funeral business. (Courtesy of Bob Forchione and Jim Rossi.)

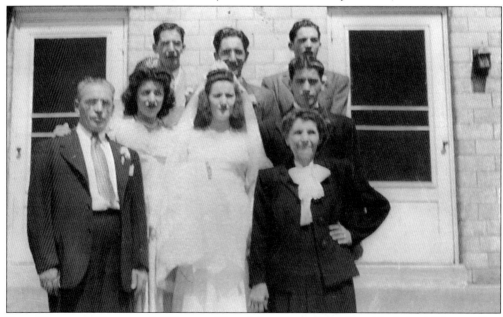

ROSSI FAMILY ON DAUGHTER'S WEDDING DAY. Adam Sr. and Rose Rossi had six children—Guy, Antoinette, Dominick, twins Mary and Mario, and Adam Jr. In this 1946 photograph, the family is photographed outside of their family home and the original Rossi Funeral Home on Tuscarawas Street in downtown Canton on daughter Mary's wedding day. (Courtesy of Bob Forchione and Jim Rossi.)

DONATA CIPRIANI PARIS IN TRADITIONAL DRESS. Donata Cipriani Paris is shown here in traditional Italian dress. (Courtesy of the John and Celia Paris Mercer family.)

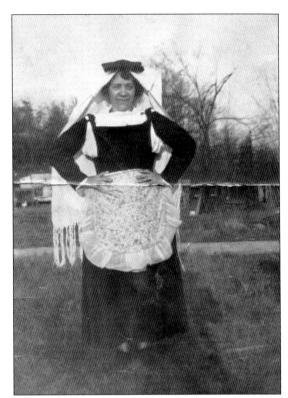

ROBERT "BOB" CAPESTRAIN AND JOSEPHINE MERCORELLI WEDDING PARTY. Josephine Mercorelli married Bob Capestrain in August 1956. Shown in the photograph are, from left to right, Ernest Ianni, Josephine Mercorelli Schiavone, James Bossic, Kathryn Sturiale Capestrain, Bob Capestrain, Josephine Mercorelli, Carl Capestrain (best man), Helen Faccini Ianni (maid of honor), Mario Mattachione, and Betty Jane Capestrain Young. (Courtesy of Bob Capestrain.)

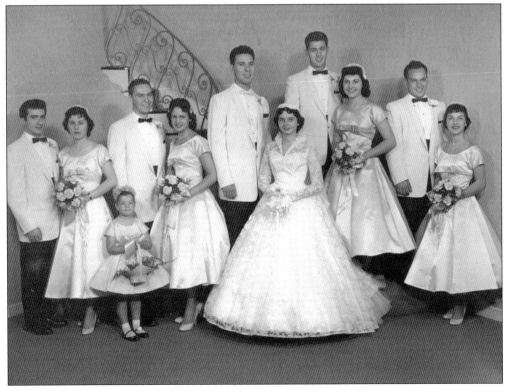

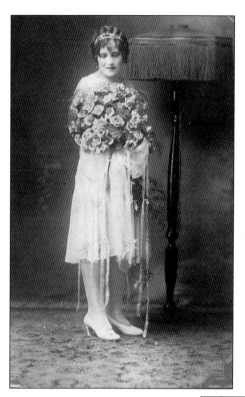

MAID OF HONOR JENNIE SPINELLI. Genoeffa "Jennie" Spinelli was one of seven children of Pietro and Algerinda DiBlasio Spinelli and was born in 1909 in Downingtown, Pennsylvania. Here, she is shown while serving as maid of honor for her friend Masalene Picciarella's wedding in Coatesville, Pennsylvania, in the mid-1920s. (Courtesy of the Luigi and Lucia Capuano family.)

JUSTINA VENTURA AND OLINDO PELOSI WEDDING. Justina Ventura was born in Rome, Italy, in 1922 to Silvio and Agata Ventura and came to the United States in 1934. She married Olindo Pelosi in April 1948 at St. Mary's Catholic Church in Massillon. Olindo, born in 1923 in Rome, Italy, to Francesco and Filomena Ammanniti Pelosi, came to the United States in 1948. The bride's sister Sandra Ventura served as maid of honor, while cousin of the groom Roberto Ammanniti served as best man. (Courtesy of the Olindo and Justina Ventura Pelosi family.)

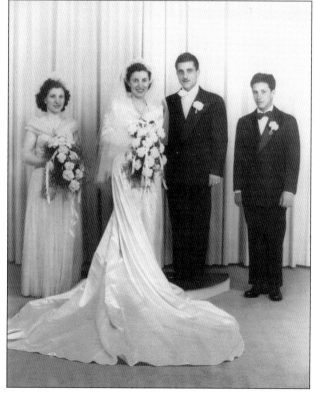

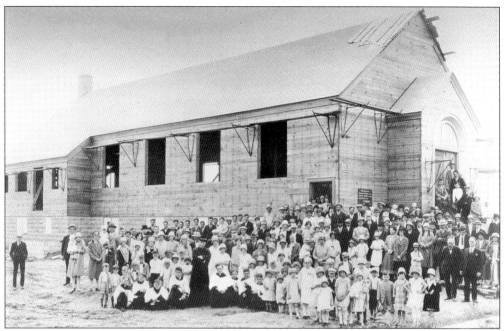

CONSTRUCTION OF ST. THERESE CHURCH IN BREWSTER, OHIO. In 1928, the parishioners of St. Therese Catholic Church took it upon themselves to build a church in their village, as opposed to traveling to St. Clement's in Navarre or St. Joseph's or St. Mary's in Massillon. Those in attendance at daily Mass included members of the Ammanniti, Belloni, Codispoti, DeAngelis, DiLoreto, Diotallevi, Gentile, Manello, Mazzaferri, Musacchia, Pelosi, Piciacchia, Pisani, Porrini, Severini, and Silvestri families. (Courtesy of Lauretta Porrini Gerber.)

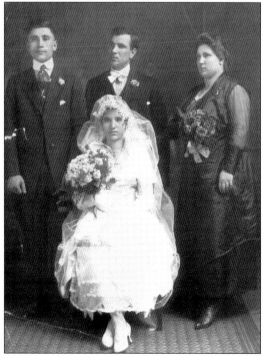

LOUIS MONSANTY AND PASQUALINA TORCASIO WEDDING PARTY. Luigi Montesanti, born in Nicastro, Italy, came to the United States in 1913 at the age of 19. He was an orphan and was employed as a laborer in a foundry in Canton. He later became an elevator operator at Wilson Rubber, where he worked until his retirement. Pasqualina Torcasio was also born in Nicastro, Italy, and came to the United States in 1910 at the age of 11, with her parents, Paolo and Angela, and her brother Luigi. (Courtesy of Greg and Sue Monsanty.)

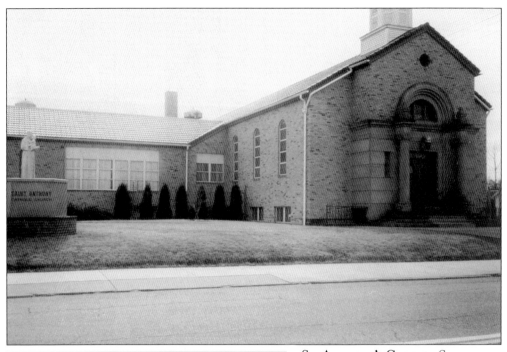

St. Anthony's Church. St. Anthony's Catholic Church has been a focal point of Italian religious and cultural life in the greater Canton area since its founding in 1908. Each year, the parishioners honor their patron saint on the Sunday closest to his June 13 feast day. The festivities include a procession through the neighborhood streets, followed by a benediction at the outdoor altar. (Courtesy of William Campolieto.)

Frank Forchione Sr. First Communion. Frank Forchione Sr. made his First Holy Communion at St. Anthony's, where he religiously served as an altar boy from the time he was in the fourth grade until the eighth grade. (Courtesy of the Frank Forchione Sr. family.)

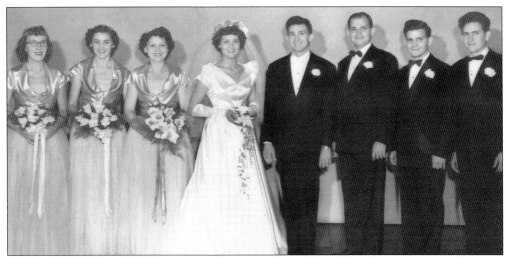

ANDYVO CODISPOTI AND LEOTA SCHANEY WEDDING PARTY. Leota Schaney married Andyvo Codispoti, a first-generation Italian American, in September 1950. Members of the wedding party are, from left to right, Betty Hill, Jeannette Cutshall, Arlene Lutz (sister of the bride and matron of honor), Leota, Andyvo, Dr. Vincent Codispoti (eldest brother of the groom and best man), Isidore Codispoti (another brother), and Dominic Lijoi (cousin of the groom). Fr. Paul J. Buchholz celebrated the nuptial High Mass. (Courtesy of Andy and Leota Codispoti.)

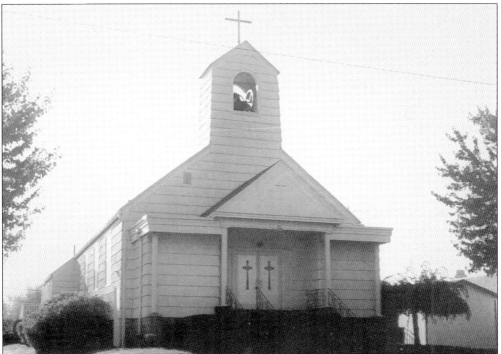

ST. THERESE CHURCH. On April 15, 1928, the Right Reverend Monsignor Clement H. Treiber officiated at the ground-breaking ceremony for St. Therese Catholic Church. Three months later, the structure was entirely completed. The plain church, constructed of concrete and wood, was dedicated by Archbishop Schrembs on September 16, 1928. That year, it was placed under the protection of St. Therese, the Little Flower of Jesus.

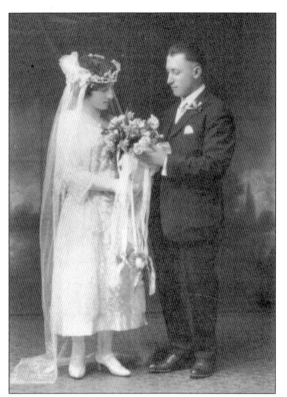

ANGELO AND FLORENCE FORCHIONE WEDDING. Florence DePasquale married Angelo Forchione in February 1923 at the original St. Anthony's Catholic Church on Liberty Street in Canton. Angelo was born in Faeto, Italy, and Florence was born in Canton. They resided in Canton, where they operated a grocery store and had five children—Frank, Angelo, John, Mary, and Vincenzo. (Courtesy of the Frank Forchione Sr. family.)

AMELIA DEANGELIS AND BRUNO MUSACCHIA WEDDING. In 1935, seventeen-year-old Amelia Marie DeAngelis was married to Bruno Musacchia by Rev. John C. Shafer at St. Therese Catholic Church. Both the bride and groom were first-generation Italian Americans who grew up in primarily Italian-speaking households and had siblings born in Italy. Amelia, who is only 4 feet, 8 inches tall, had to stand on a box for this photograph.

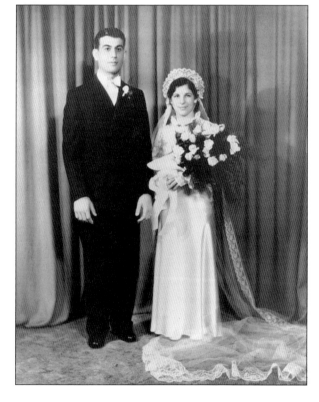

ANTHONY DOTTAVIO AND ANGELINE MUSACCHIA WEDDING.
Anthony Dottavio and Angeline Musacchia were married in June 1946 at St. Therese Catholic Church. Anthony was born in 1911 to Alessandro Dottavio and Giovina DiPietro. When he was three years old, and his brother Joseph was only one, their mother passed away. Their father, Alessandro, then married Luisa Lelli, who was born in Guilanova, Italy. Alessandro and Luisa had six more children before Alessandro passed away in 1926. Luisa then married Bruno Morabito.

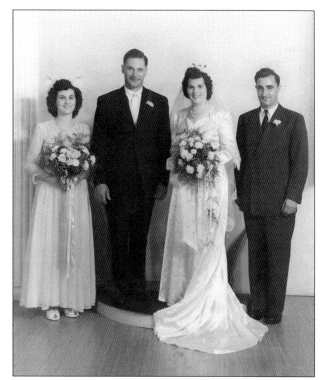

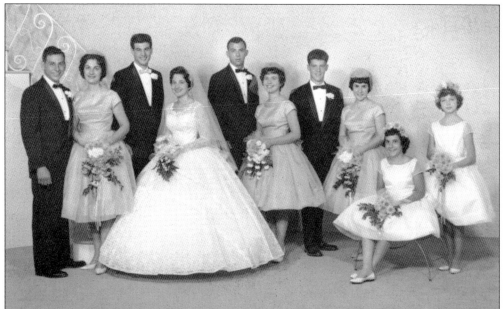

JOSEPH MUSACCHIA AND EMMY LOU REAM WEDDING PARTY. Emmy Lou Ream married Joseph Anthony Musacchia in September 1961 at St. Therese Catholic Church. Also in the wedding party are, from left to right, Ronald Musacchia (brother of the groom), and Mary Kay Kemer Musacchia (sister-in-law of the groom), Marion DeAngelis (cousin of the groom), Kathleen Ream (sister of the bride), Richard Ream (brother of the bride), Victoria Musacchia (sister of the groom), Rita Ann Musacchia (sister of the groom), and Roberta Ream (sister of the bride).

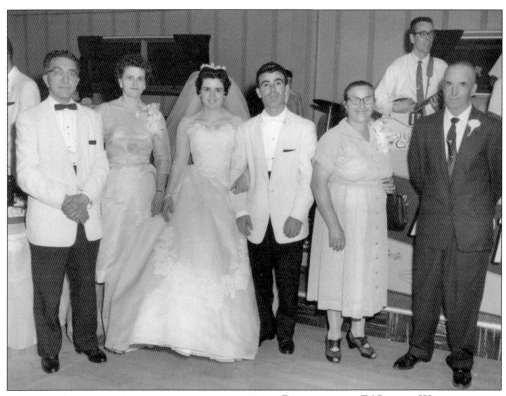

BERNARD AND D'ORAZIO WEDDING.
Mary Ann Bernard married Marcurio "Mike" D'Orazio in 1960 at St. Michael's Catholic Church in Canton. Marcurio, who was born in Montenerodomo, Italy, in 1935 to Fidel and Giovina D'Antonio D'Orazio and came to the United States in 1954. Mary Ann was born in Ohio in 1941 to John and Lucy Ziccardi Bernardo. (Courtesy of Marcurio "Mike" and Mary Ann Bernard D'Orazio.)

ANNA AMMANNITI AND OTTAVIO DIOTALE WEDDING. Anna Ammanniti, born in 1909 in Ohio, married Ottavio Diotallevi in April 1928 at St. Therese Catholic Church. Ottavio was born in 1904 in Capitignano, Italy. His brother Nick served as his best man, while Anna's friend Louise Belloni Morris served as the maid of honor. Ottavio and Anna resided in Brewster and had 10 children—Dante, Joseph, Angelina, Mary, Christopher, David, Laura, Rose, Linda, and Otto. (Courtesy of Karen Diotale Kelly.)

RALPH AND ANNA COLUCCI WEDDING.
Ralph Colucci, born in Vastogirardi, Italy,
in 1881 to D'Adot "David" and Mary Leone
Colucci, came to the United States in 1900.
D'Adot was born in Avellino, Italy, and was
said to have been close to seven feet tall.
Anna Marie Cincinat was born in Ohio in
1887, and she and Ralph were married in
May 1906 at St. Clement Catholic Church
in Navarre. Ralph worked as a laborer
in the gravel pits, and they lived on Italy
Hill in Navarre. There, they raised their
eight children—David, Joseph, Raymond,
Alverda, Rafael, Eugene, Leonard, and
Ronald. (Courtesy of the Colucy family.)

GUIDONE AND CAROZZI WEDDING. Anna
Guidone married Frank Carozzi in June
1963 at St. Peter's Catholic Church in
Canton. Mary Jane Baxter served as the
maid of honor. Shown here are, from
left to right, Sabatino Guidone, Esther
Guidone, Anna Guidone, Frank Carozzi,
Carmela Carozzi, and Nick Carozzi.
(Courtesy of Anna Guidone Carozzi.)

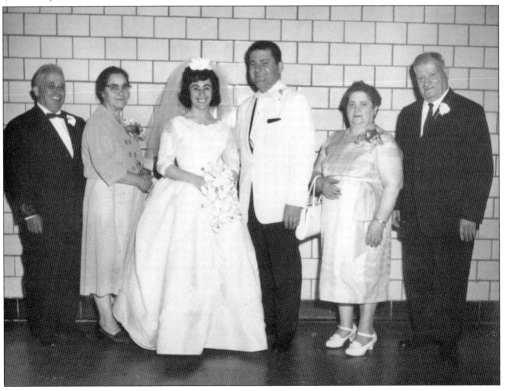

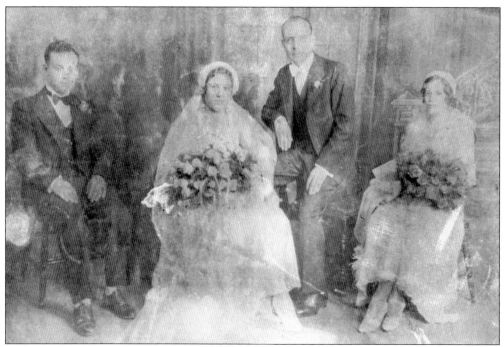

VINCENZO AND CONCETTA ORSETTI WEDDING. Vincenzo Orsetti was born in 1896 in Ascoli Piceno, Italy, and came to the United States in 1914 on the immigration vessel SS *Prinzess Irene*. He married Ohio native Concetta Pasquale in the early 1930s in Youngstown, Ohio. In 1937, Vincenzo and Concetta moved to Alliance and raised three daughters—Carolyn, Carmella, and Jeannette. (Courtesy of Carmella Orsetti Stippich and Carolyn Orsetti Durm.)

RAFAEL COLUCY AND MILDRED SAMSA WEDDING DAY. Mildred Samsa was born in 1923 in Ohio to Joseph and Mary Viront Samsa. Joseph was born in 1888 in Slovenia and came to the United States in 1913, and Mary was born in 1893, also in Slovenia, and came to the United States in 1920. Of their six children, Joseph and Peter were born in Yugoslavia, and Mildred, Tony, Josephine, and Anna were born in Ohio. Mildred married Rafael Colucy, son of Ralph and Anna Colucy, and they had three children—Jeff, Carter, and Mary Ann. When Carter was only six weeks old, Rafael was drafted by the US Army and spent two years away from home. Rafael and Mildred lived in Navarre, and Rafael worked in the coal mines. (Courtesy of the Colucy family.)

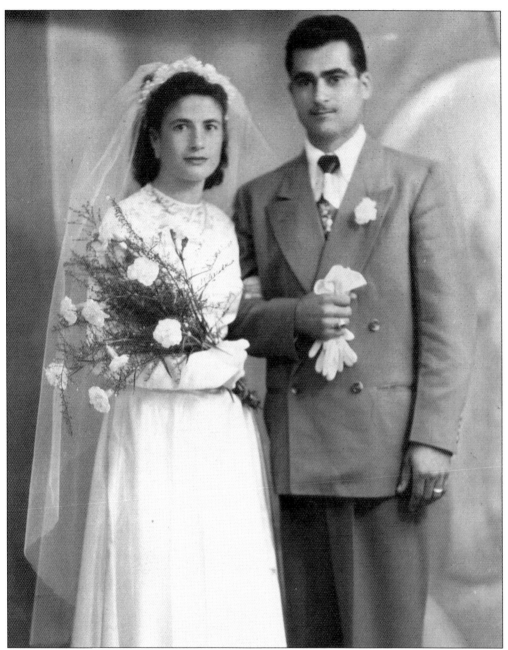

GABRIEL AND ELVIRA PELOSI WEDDING. Elvira Tudini was born in Aquila, Italy, to Augusto and Chiara Tudini and came to the United States in 1951 on the immigration vessel SS *Vulcania*. Elvira is pictured here on her wedding day to Gabriel Pelosi. Gabriel was born in the United States in 1923 to Georgio and Maria Cianfarini Pelosi. Georgio first came to the United States in 1912 when he was single, settled in Brewster, and painted engines on the railroad. He returned to Italy to marry Maria. As a result of his exposure to lead paint at that time, his doctor advised him to return to Italy for health reasons. Therefore, shortly after Gabriel's birth, the family returned to Italy. Gabriel then returned to the United States in 1951. (Courtesy of the Gabriel and Elvira Tudini Pelosi family.)

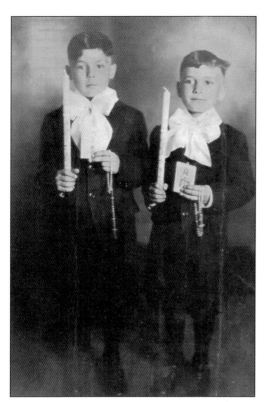

ANTHONY AND OLIVER MAZZAFERRI FIRST HOLY COMMUNION. Brothers Anthony (left) and Oliver Mazzaferri made their First Holy Communion at St. Therese Catholic Church in Brewster. The boys were both born in Brewster to Giovanni and Lucia Ventura Mazzaferri. Anthony graduated from Brewster High School and received his bachelor of science and master's degrees from Loyola University in Chicago. In 1960, he sailed from New York to Italy for a year of study at the University of Perugia (50 miles from where his parents were born) on a combination of Fulbright and Italian government scholarships. He also served his country for two years with the US Air Force. (Courtesy of Bonnie Mazzaferri Dourm.)

MARY GRACE AND ELVIO MAZZAFERRI FIRST HOLY COMMUNION. Brother and sister Mary Grace and Elvio Giovanni Mazzaferri made their First Holy Communion at St. Therese Catholic Church in Brewster. Mary Grace was born in Dennison, Ohio, while her six siblings were all born in Brewster. She married Angelo Crimaldi in 1942, also in St. Therese Catholic Church. Angelo, the son of Sam and Theresa Crimaldi of Greentown, worked on the railroad. Sam and Theresa were both born in Italy and came to the United States in 1906. (Courtesy of Bonnie Mazzaferri Dourm.)

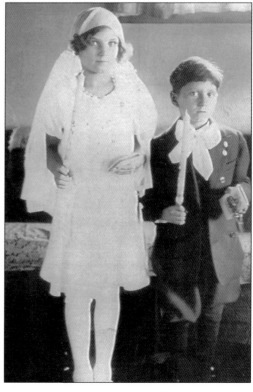

GINA GENTILE PETERS FIRST HOLY COMMUNION. Gina Gentile made her First Holy Communion at St. Therese Catholic Church in Brewster. Gina was born in Capitignano, Italy, in 1925 and came to the United States with her parents, Mariano and Josephine, as an infant. Gina married Emil Peters, a mailman and resident of Akron, in 1948. Emil was the son of Joseph and Theresa Marchionna Peters. (Courtesy of Bonnie Mazzaferri Dourm.)

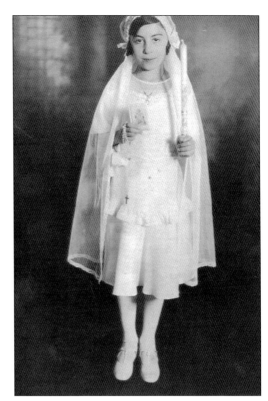

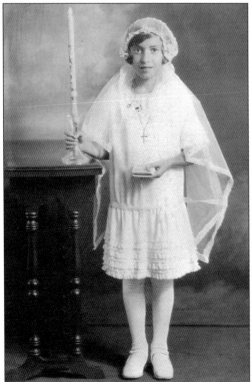

OLIMPIA GENTILE MUZI FIRST HOLY COMMUNION. Olimpia Gentile, Gina's sister, also made her First Holy Communion at St. Therese. Olimpia, born in Capitignano in 1920, came to the United States with her family in 1925. In 1947, she married Anthony Muzi, the son of Steve and Giustina Muzi of Akron. Steve and Giustina were born in Italy and came to the United States in 1920. (Courtesy of Bonnie Mazzaferri Dourm.)

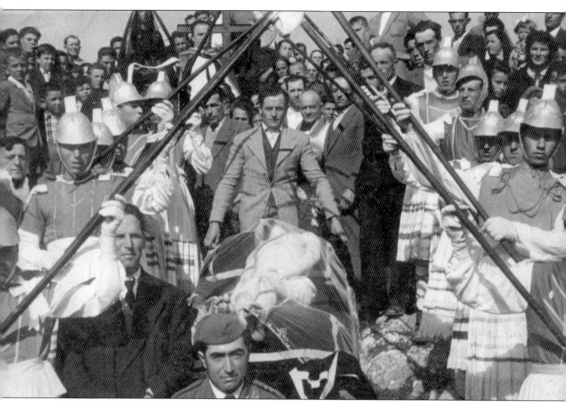

GOOD FRIDAY PROCESSION IN ITALY. In 1953, Marcurio D'Orazio (far left, with helmet) participates in the traditional Good Friday procession in his hometown of Montenerodomo, Italy. The event commemorates the taking of Jesus to the Roman soldiers. (Courtesy of Marcurio "Mike" and Mary Ann Bernard D'Orazio.)

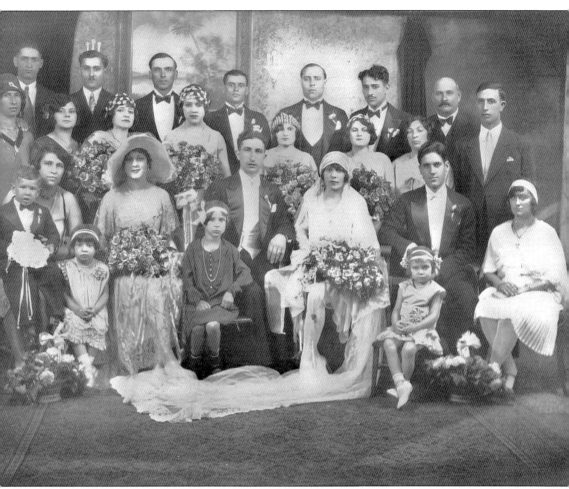

TOMASO CHIUDIONI WEDDING. Mary Ciofani married Tomaso Chiudioni in Cleveland in August 1929. Tomaso was born in Italy in 1901 to parents Octavio and Cetima, and Mary was born in Republic, Pennsylvania, in 1913 to Antonio and Julia Torchi Ciofani. Included in the photograph are Silvio (last row, far left) and Anna Chiudioni DeAngelis (third row, far left), and their two daughters, Gina (first row, far left) and Antoinette (first row, second from left) of Brewster. Anna and the groom were first cousins. (Courtesy of Greg and Sue Monsanty.)

JOHN BERNARD AND LUCY ZICCARDI WEDDING. Lucy Ziccardi and John Bernard were wed in September 1937 at St. Anthony's Catholic Church. John, a barber at Fourth Street and Clarendon in Canton, was born in Dysart, Pennsylvania, to Rocco and Nulia Arista Ziccardi; and Lucy was born in Canton, Ohio, to David and Marie Ribbilitti Bernard. (Courtesy of Marcurio "Mike" and Mary Ann Bernard D'Orazio.)

CARMELA TRISTANO ENGAGEMENT. Carmela Tristano is pictured here in her formal engagement portrait. Her fiancé was Archangelo Marchione. Carmela was born in Ohio in 1907 to parents who originated in Vastogirardi, Italy. Archangelo was born in Vastogirardi in 1897 and came to the United States in 1921 to learn the shoe-repair trade. The couple resided in New Philadelphia in Tuscarawas County. (Courtesy of Gloria Marchione Talarico.)

JENNIE SPINELLI CONFIRMATION. Genoeffa "Jennie" Spinelli is seen here on her confirmation day in Downingtown, Pennsylvania. She is pictured with Filomena DiBerardini. Jennie's parents were Pietro and Algerinda DiBlasio Spinelli. (Courtesy of the Luigi and Lucia Olivieri Capuano family.)

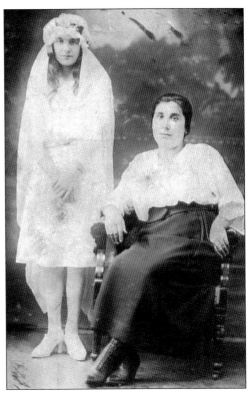

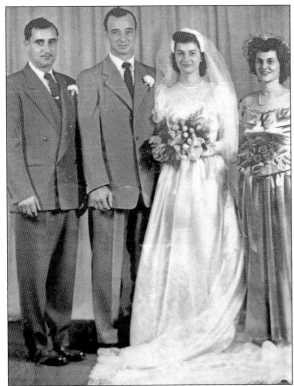

MATTHEW AND CAROLINE CHATTERELLI WEDDING. The wedding of Caroline Delassandro and Matthew Chatterelli took place in October 1950 at St. Agnes Catholic Church in Orrville. Caroline was the daughter of Louis Delassandro and Matilda Prelup. Though of Italian descent, Louis was born in Sao Paolo, Brazil, and worked on a coffee plantation before moving to Orrville. (Courtesy of Matthew and Caroline Chatterelli.)

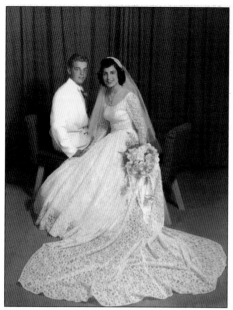

JAMES GRILLON AND ANTONETTE MUSACCHIA WEDDING. James Grillon was born in Ohio in 1929 to Paul and Freida Stockle Grillon. Paul and Freida were both born in Switzerland and settled in Navarre, where Paul baked bread for a living. In 1951, James married Antonette "Nini" Musacchia, the youngest daughter of Castenze and Ursula Musacchia. James also served his country in the US Army in 1951. (Courtesy of the James and Antonette Grillon family.)

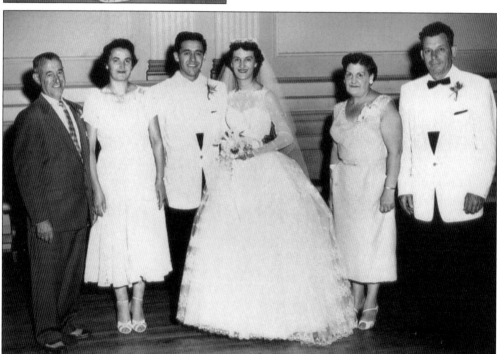

LUIGI CAPUANO AND LUCILLE OLIVIERI WEDDING. Luigi "Louie" Capuano married Lucia "Lucille" Olivieri in 1956 at St. Joseph's Catholic Church in Canton. Pictured are, from left to right, Luigi Capuano Sr., Antoinette Capuano (Luigi's stepmother), Luigi Capuano Jr., Lucia Olivieri Capuano, Jennie Olivieri, and Anthony Olivieri. Anthony was born in Nereto, Italy, in 1902; came to the United States in 1920; and settled in Conshohocken, Pennsylvania, where he married Genoeffa Spinelli in 1928. In 1932, they moved to Stark County, where Anthony worked in construction and they raised five children—Alfred, Lucille, Rita, Dorothy, and Anthony Jr. (Courtesy of the Luigi and Lucia Olivieri Capuano family.)

Three

FAMILY AND FRIENDS

La famiglia, or "the family," is of supreme importance in the Italian heritage. While Italy and the Italians have suffered invasions, wars, occupations, and temporary leaders throughout history, the family has persevered. The family provides a sense of belonging, a built-in social network, and a constant support system. Respect for one's mother and father and defense of one's siblings at all costs are values that are deeply ingrained. This sense of loyalty means obeying parents and attending extended family members' major life events (baptisms, First Communions, confirmations, and birthdays). It also means Sunday pasta dinners with extended family and *paesans* ("friends")—usually after attending Mass. Tradition is a very important aspect of family life, creating the bonds that hold the Italian family together. As the Italian Luigi Barzini wrote, "No Italian who has a family is ever alone."

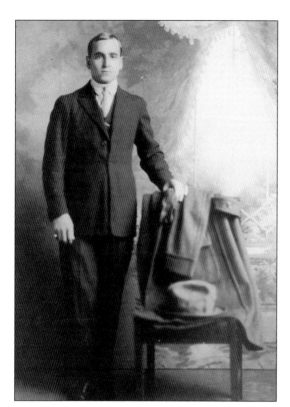

GIOVACCHINO CAVICCHIA. Even if an Italian did not possess material wealth, his appearance was extremely important. In this photograph, Giovacchino shows off his fashion sense not long after arriving in the United States from Capitignano, Italy, in 1912.

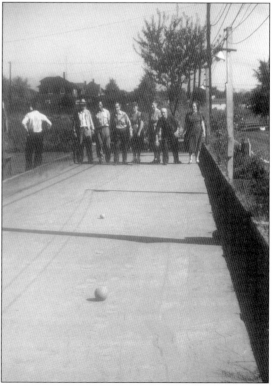

BOCCE BALL TOURNAMENT AT CAVICCHIA'S RESIDENCE. The game of bocce ball dates back to Roman times. Giovacchino "Jack" Cavicchia loved it so much that he built a bocce ball court in his backyard in Brewster, where he hosted tournaments on the weekends. (Courtesy of Greg and Sue Monsanty.)

Servilliano "Silvio" Ventura.
Silvio Ventura was born in
Capitignano, Italy, in 1895. He served
in World War I in Italy before coming
to the United States in 1923. Silvio
held several jobs before opening a
shoe-repair shop in Massillon. In
1932, he became a US citizen, and
two years later his wife, Agata, came
to the United States with their four
children—Ida (who would marry
Norman Potter), Justina (who would
marry Olindo Pelosi), Sandra (who
would marry John Sibila), and
Rinaldo. After Silvio's retirement,
Ida and Norman operated the City
Shoe Hospital in Massillon for 31
years. (Courtesy of the Olindo and
Justina Ventura Pelosi family.)

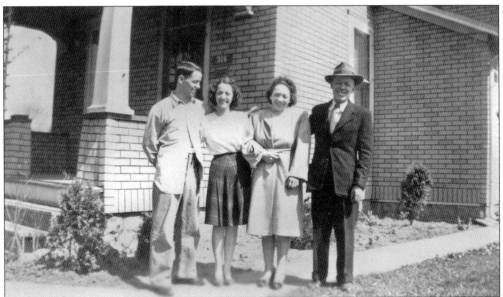

Donata Cipriani and Frank Paris with Celia and Bernard. Donata Cipriani came to the
United States in 1916 from Pettorano sul Gizio, Italy, and was married shortly thereafter to Frank
Paris. The couple resided in Brewster and had two daughters, Celia and Mary, and two sons, Robert
and Bernard. Shown here are, from left to right, Bernard, Celia, Donata and Frank. (Courtesy
of the John and Celia Paris Mercer family.)

MARY CIPRIANI FERRELLI (FRAILLY) AND CHILD. Mary Cipriani was born in 1888 in Pettorano sul Gizio, Italy, and came to the United States in 1916. She married Dan Ferrelli, whose last name was Americanized to Frailly when he came to the United States, and the couple resided in Brewster and had seven children—Gidio, Pat, Nancy, Tony, Nellie, Rose, and Robert. (Courtesy of the John and Celia Paris Mercer family.)

CONCETTA ORSETTI WITH DAUGHTERS. Concetta Pasquale Orsetti (left) is pictured on Easter Day in Alliance with her three daughters—Carmella (center), Carolyn (right), and Jeannette (kneeling). Concetta and her husband, Vincenzo, were two of the original members of the Roma Society in Alliance. Today, daughters Carmella and Carolyn own and operate the Italian social club. (Courtesy of Carmella Orsetti Stippich and Carolyn Orsetti Durm.)

FRANK PARIS'S PARENTS. Frank Leonard Paris, originally named Leonardo Trombe, was given up at birth and lived in a children's home in Rome, Italy. He was adopted by Bernardo and Maria Paris, pictured here, and his name was changed to Frank Leonard Paris. (Courtesy of the John and Celia Paris Mercer family.)

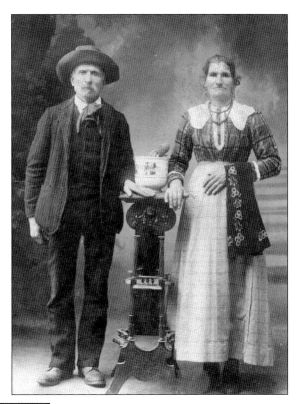

DONATA CIPRIANI PARIS. Donata Cipriani Paris was born in 1897 in Pettorano Sul Gizio, Italy, to Pasquale and Liberata Ferrelli Cipriani; came to the United States in 1916; and married Frank Paris. She had two sisters, Louisa and Maria. Louisa and her husband, Giovanni Panza, had a daughter, Crescenza. Shortly after Crescenza's birth, Louisa passed away, and Giovanni remarried Francesca Di Fonzo. Francesca and Giovanni had a son, Angelo, and Giovanni came to the United States in 1920. Francesca, Crescenza, and Angelo followed in 1921. (Courtesy of the John and Celia Paris Mercer family.)

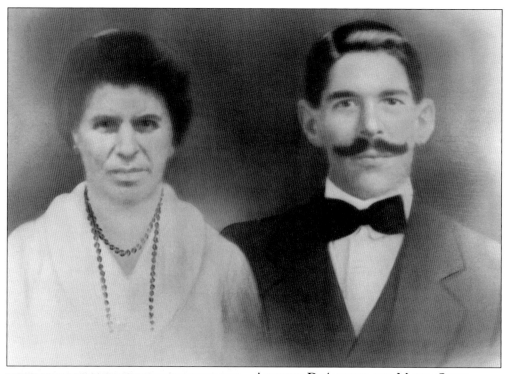

ANTONIO DEANGELIS AND MARIA OVIDI.
Antonio DeAngelis was born in 1886 in Abruzzi, Italy, to Mariano and Vittoria Pucci DeAngelis and came to the United States in 1913 on the immigration ship SS *La Touraine* and met his cousin Enrico Consolidani in Dennison. His first wife, Maria Ovidi, was born in 1880 in Amatrice, Italy, to Antonio and Emidia Ficcadenti Ovidi. Maria sailed on the immigration ship SS *Patria* in 1915 with their three children—Clorinda, Ferminia, and Mariano. While living in Brewster, Maria gave birth to two additional children, Amelia and Michael. Shortly after Michael's birth, Maria succumbed to "La Spagnola" (the Spanish flu epidemic) in 1918.

ANNA "NANI" CHIUDIONI. Nani's sister, Teodora, was scheduled to travel to the United States in 1921 from Norcia, Italy. On the date of departure, however, when Teodora went to board the ship, it was discovered that she had an eye infection. As a result, she was not permitted to board. Nani was there, and since their father, Ottavio, had already purchased the nonrefundable ticket, she came to the United States in place of her sister. (Courtesy of Greg and Sue Monsanty.)

Silvio DeAngelis and Anna Chiudioni DeAngelis. Silvio DeAngelis was born in 1897 in Norcia, Italy, and came to the United States in 1920. His brother, Pete, was born in 1893 and immigrated in 1911. In 1930, Pete was living in Brewster with Silvio; Silvio's wife, Anna; and their two daughters, Antoinette and Gina. Silvio became a naturalized citizen in 1940. Both brothers worked on the railroad. (Courtesy of Greg and Sue Monsanty.)

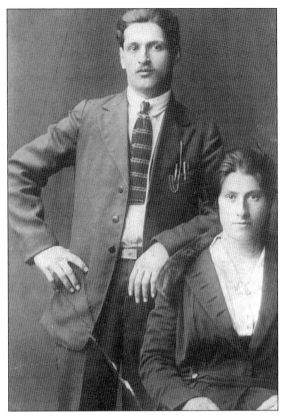

Castenze and Ursula Petralia Musacchia Family. Castenze Musacchia and Ursula Petralia Musacchia are pictured here in the St. Therese parish hall with their seven children—Matteo, Bruno, James, Benedetta, Josephine, Angeline, and Antonette. Castenze was very proud to become a US citizen; while studying for his examination, he would walk around the house quizzing his children, "Who was the first president of the United States?"

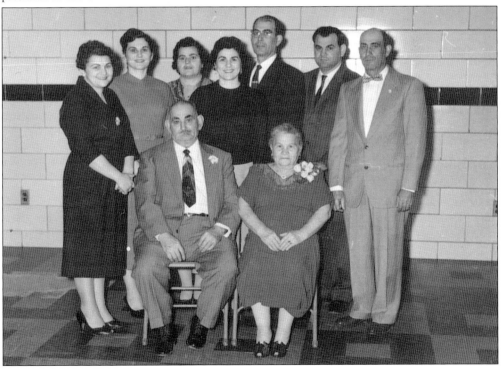

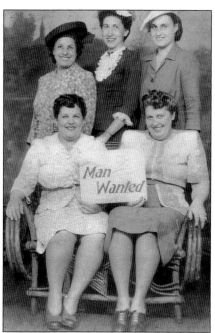

MAN WANTED. Pictured here are (front row) Amelia DeAngelis Musacchia and Etta Mae Marchbank D'Anniballe; (back row) Ferminia DeAngelis Cavicchia, Louise Belloni Morris, and Jeannette DiLoreto Porrini. Fortunately, the Man Wanted sign worked for all five of these women: they all married and had 17 children among them. Amelia married Bruno Musacchia in 1935, Etta Mae married Guido D'Anniballe in 1933 in West Virginia, Ferminia married Giovacchino Cavicchia in 1929, Louise married Harry Morris in 1935, and Jeannette DiLoreto married Michael Porrini in 1933.

FRIENDS AT BREWSTER LAKE. This photograph, taken in 1943, shows Italian friends vacationing at Brewster Lake. The only identified individuals are (first row) Eleanor Severini (far left), Josephine Musacchia (second from left), and Anna Severini (right); (second row) Gina DeAngelis (fourth from left), Olimpia Gentile (seventh from left), Angeline Musacchia (second from right), and Antoinette DeAngelis (right); (third row) Nick Soehnlen (second from right) and Father Buchholz (right). (Courtesy of Antoinette DeAngelis.)

CAPUANOS AND FERREROS. In this 1942 photograph are, from left to right, Betty Capuano, Mrs. Rocco Ferrero, Rocco Ferrero, Vince Ferrero, and Luigi and Margaret Capuano. Margaret and Luigi were born in Frosinone, Italy, and came to the United States in 1924 for a better life. They settled in Canton, and Luigi initially worked in the brickyard and then joined Republic Steel. They belonged to the Marco Tullio Society, Northern Italian Club, Dante Alighieri Club and the Sons of Italy. As in the majority of Italian households, Sunday dinners at the Capuanos always included some form of homemade pasta and sauce. (Courtesy of the Luigi and Lucia Olivieri Capuano family.)

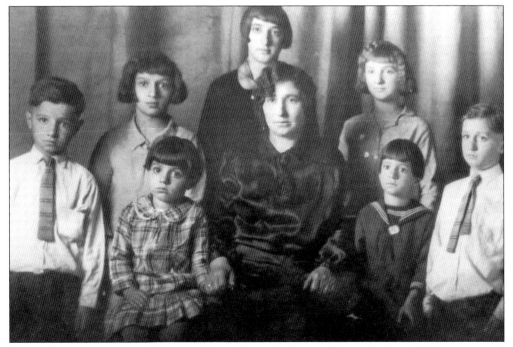

LUCIA CHATTERELLI WITH CHILDREN. Lucia Bastardo, born in Foggia, Italy, in 1889, was married to Dominic Tozzi. Upon Dominic's death in 1910, possibly from malaria, Lucia decided to leave for the United States with her young children. She settled in Orrville, Ohio, remarried Giuseppe Chatterelli in Summit County, and raised four additional children. Pictured, from left to right, are (front row) Matthew, Carmel, Lucia, Aggie, and Angelo; (back row) Edith, Minnie, and Katie. (Courtesy of Matthew and Caroline Chatterelli.)

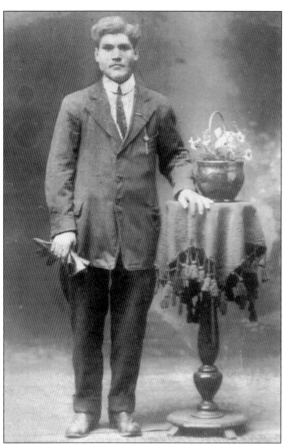

PIETRO COLETTI. Pietro Coletti was born in Montenerodomo, Italy, to sharecropper parents. He had three brothers and two sisters. Elder brother Joseph came to the United States first, followed by Pietro, and then Frank. Their elder brother, Martino, stayed in Italy. Pietro found employment as a policeman, on the railroad, and then with Republic Steel. However, he had to travel back to Italy to serve in the Italian army. While there, he met and married Maria Gialucca. The pair returned to the United States, settled in Canton, and attended church at St. Anthony's. (Courtesy of Sam Coletti.)

D'AURELIO FAMILY CHRISTMAS. Pasquale D'Aurelio was born in Italy in 1889 and came to the United States in 1901 as an infant. He married Concetta Micciche, and they resided in Canton with their eight children—Albert, Alfred, Mary, Anna Francis, Joseph, Jennie, Carmel, and Guy. This photograph shows them celebrating Christmas in their family home. (Courtesy of Jim Angello.)

CLARA CAPESTRAIN. Clara Capestrain, the daughter of Rose and Sam Capestrain, was born in 1929 in Canton. Tragically, she contracted pneumonia and died at the very young age of seven in 1936. (Courtesy of Bob Capestrain.)

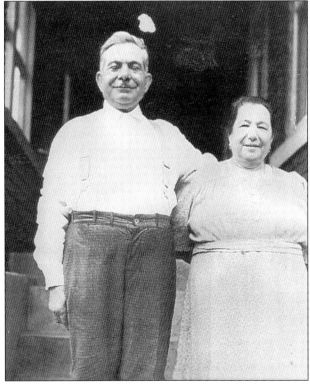

MIDIO AND NICOLINA DIANO. Midio Diano was born in Italy in 1876 and came to Stark County with his wife, Nicolina, in 1905. They lived on Liberty Street in Canton and raised five children—Carmela, Anthony, Frank, Lucia, and Sally. (Courtesy of Darlene Diano Guynup.)

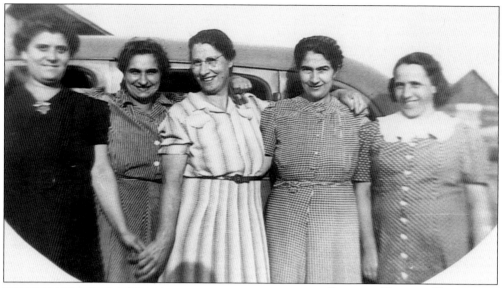

LIFELONG FRIENDS. Shown here from left to right, Nettie Norcia, Anna Diotallevi, Anna DeAngelis, Angeline Diotallevi, and Annie Severini are enjoying one another's company. All five were born in Italy and settled in Stark County. (Courtesy of Karen Diotale Kelly.)

MARIA COLETTI. Maria Gialucca was born in Montenerodomo, Italy, in 1891. She married Pietro Coletti, and together they came to the United States in 1919 and settled in Canton. There, they attended St. Anthony's Catholic Church and had three children—Richard, Perlini, and Sam. (Courtesy of Sam Coletti.)

ANTOINETTE DEANGELIS IN UNIFORM WITH SANTA. Antoinette DeAngelis (right) and Margaret Burk pose with Santa Claus in Washington, DC, in December 1945 while serving in the Women's Army Corps (WAC). Antoinette and Margaret were two of the 150,000 American women to serve in the WAC during World War II. Members of the WAC were the first women, other than nurses, to serve within the ranks of the US Army. (Courtesy of Greg and Sue Monsanty.)

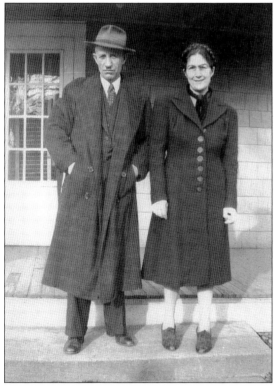

ANGELINA DIOTALE. Angelina and Silvio Diotale lived in Brewster with their daughter Diana. In 1949, Angelina and Diana spent a three-month vacation in Italy visiting family and friends. (Courtesy of Greg and Sue Monsanty.)

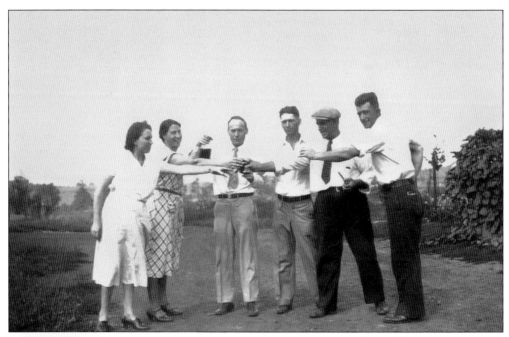

ANNA AND SILVIO DEANGELIS TOASTING WITH FRIENDS. Anna DeAngelis (second from left) and Silvio DeAngelis (fourth from left) are pictured with friends in a vineyard, toasting the fruits of their labor. (Courtesy of Greg and Sue Monsanty.)

MATTHEW, BRUNO, AND JAMES MUSACCHIA. Pictured here, from left to right, are brothers Bunu "Bruno," James, and Matteo "Matthew" Musacchia. Matteo was born in 1911 in Amatrice, Italy, and came to the United States in 1913 with his mother, Ursula. Bunu was born in 1914 in the United States, and James followed in 1916. Matteo married Bridget Crème, the daughter of Nick and Angela Digio Crème. Nick was born in 1883 in Italy and came to the United States in 1909, and Angela was born in 1883 in Italy and came to the United States in 1910. In 1936, youngest brother James married Angeline Falasco, who was born in Ohio in 1918 to Augusta and Nicoletta Falasco. Bruno married Amelia DeAngelis in 1935. (Courtesy of the Bruno and Amelia Musacchia family.)

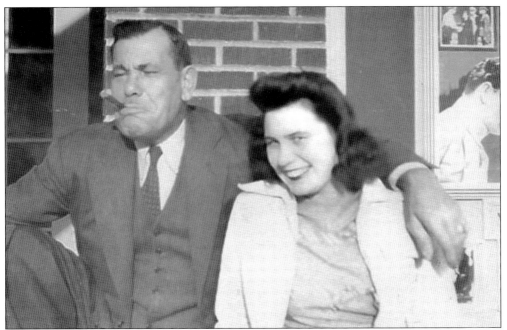

Marion Belloni with Dorothy Burcaw. Marion Belloni is pictured here with fellow Brewster resident Dorothy Burcaw in front of the Brewster Theater, which was built and operated by Marion and his wife, Annunziata. Dorothy was born in 1928 in Ohio to George and Mary Burcaw. She attended Mercy Hospital School of Nursing in Canton and served in 1944 in the World War II Cadet Nursing Corps. (Courtesy of Marion "Buzz" Belloni.)

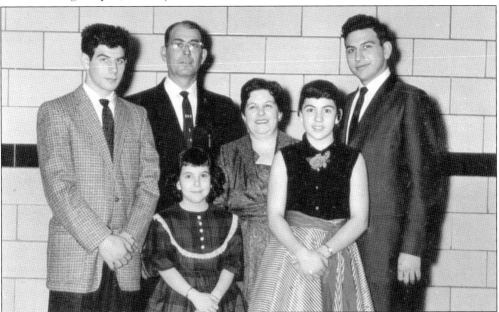

Bruno and Amelia Musacchia Family. Bruno Musacchia and Amelia DeAngelis were married at St. Therese Catholic Church in Brewster. They subsequently settled in Brewster and raised four children—from left to right, Joseph, Rita Ann, Victoria, and Ronald. They are pictured in St. Therese Church Hall in the 1950s. (Courtesy of the Bruno and Amelia Musacchia family.)

BRUNO AND AMELIA MUSACCHIA FAMILY WITH ANTONIO DEANGELIS. Pictured here are Bruno and Amelia Musacchia with three of their four children—from right to left, Victoria, Joseph, and Rita Ann. In the background is Antonio DeAngelis, Amelia's father. Before immigrating to the United States, Antonio had been a personal chef for an Italian prince and princess. (Courtesy of the Bruno and Amelia Musacchia family.)

BRUNO MUSACCHIA. Bruno Musacchia graduated from Brewster High School in 1933 and immediately started working. He was an entrepreneur and started Bruno Construction Co., which he operated with his brother-in-law, sons, and son-in-law. Many sidewalks in Brewster still bear the company's stamp. (Courtesy of the Bruno and Amelia Musacchia family.)

RONALD AND JOSEPH MUSACCHIA WITH BREWSTER GAS STATION IN BACKGROUND. Brothers Ronald and Joseph Musacchia are pictured here in the 1940s in front of the Brewster Gas Station. Ronald was born in 1936 and graduated from Central Catholic High School in Canton in 1954. Joseph, born in 1940, graduated from Brewster High School, where he ran track and played football, basketball, and baseball for the Brewster Railroaders. (Courtesy of the Bruno and Amelia Musacchia family.)

ANTONIO DEANGELIS. Antonio DeAngelis (far right), from Capitignano, Italy, came to the United States in 1913. His wife, Maria, followed in 1915 with their three children. Here, Antonio is sharing a toast with friends outside the family's home.

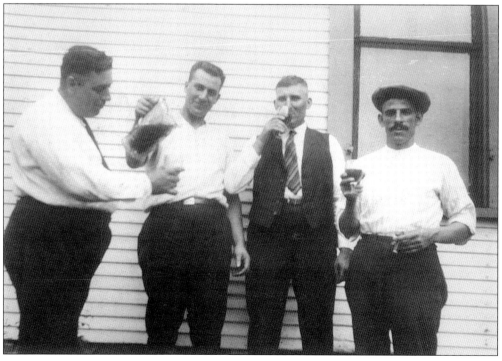

PASQUALE DICOLA. Pasquale "Patsy" DiCola, one of eight children of Giacomo "James" DiCola and Elisabetta "Elizabeth" Trilli DiCola, was born in 1909 in Ohio. His siblings were Herman, Victor (named after Vittorio Emmanuel), Mary, Ben (Baradino), Lawrence (Lorenzo), Jennie (Giovanna), and John. The family resided in Canton, and this photograph was taken in 1928. (Courtesy of Christine DiCola.)

BEN DICOLA WITH SISTER MARY. Ben DiCola is pictured here with his sister Mary. Mary was born in 1910 in Ohio and married Raffaele Cozzoli. Ben, born in 1911, married Vincenza "Virginia" Panella in 1940. (Courtesy of Christine DiCola.)

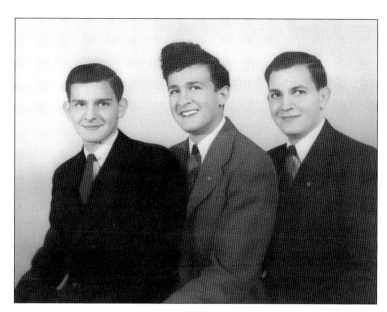

CODISPOTI BROTHERS. Shown are Bruno and Maria Codispoti's three sons—from left to right, Isidore, Andyvo, and Vincent. Bruno and his sons were members of the St. Andrea Ionian Society, an Italian American benefit society founded in 1936 and still in existence today. (Courtesy of Andy and Leota Codispoti.)

LOUISA AND LEONARDO PANELLA. Leonardo Panella was born in Greci, Italy, in 1895 and came to the United States in 1913. He and Louisa had six children—twins Vern and Michael, Joseph, Marie Antoinette, Esther Rose (named after the Jewish midwife who lived next door), and Augustino. (Courtesy of Christine DiCola.)

GIACOMO AND ELISABETTA DiCOLA. Giacomo DiCola was born in Roccarozzi, Italy, in 1874 and came to the United States in 1896. He initially worked in the brickyards in Waynesburg and then the coal mines in East Palestine. When one of the coal mines collapsed, Giacomo broke his back and was no longer able to work in the mines. At that time, he opened a grocery store in Waynesburg. (Courtesy of Christine DiCola.)

BEN AND VERN DiCOLA WASHING DISHES. Ben and Vern DiCola are seen here washing dishes at their family home in Canton. (Courtesy of Christine DiCola.)

MAZZAFERRIS AND GENTILES. John and Lucia Mazzaferri (left) are seen here celebrating their 50th wedding anniversary. Also pictured are Lucia's sister Josephine and her husband, Mariano "Mike" Gentile. (Courtesy of Bonnie Mazzaferri Dourm.)

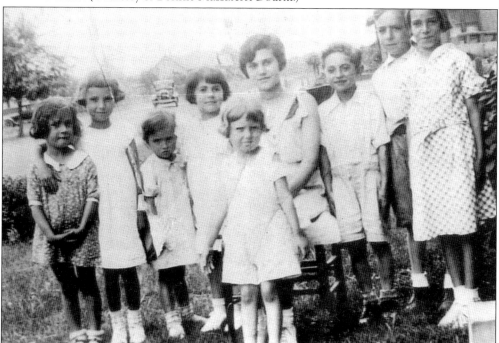

BREWSTER FRIENDS. Childhood friends, from left to right, Virginia Ammanniti, Flora Mazzaferri, Angie Diotallevi, Antonette Musacchia, Angelina Mazzaferri (in front), Josephine Musacchia, Dante Diotallevi, Dominic Cavicchia, and Maria Cavicchia pose for a photograph in Brewster in 1938. (Courtesy of Karen Diotale Kelly.)

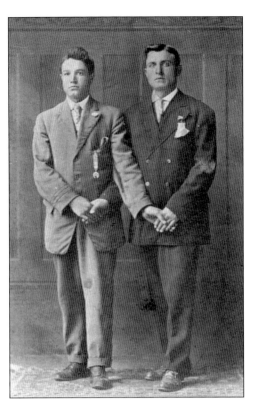

D'AURELIO MEN HOLDING HANDS. Pasquale D'Aurelio is pictured here with his father, Gaetano D'Aurelio. Pasquale was born in Italy in 1888 and came to the United States in 1901. Gaetano, born in 1851, came to the United States in 1890. Pasquale initially lived in Dennison and worked in the coal mines. He came to Stark County around 1920. (Courtesy of Jim Angello.)

ANTHONY TRISTANO WITH SISTER CARMELA MARCHIONE. Anthony Tristano is pictured here with his sister Carmela Tristano Marchione. Carmela, the only daughter of Cherubina Amicone and Pasquale Tristano, married Archangelo Marchione, with whom she had six children. Unfortunately, Archangelo passed away in 1941 at the young age of 45. At his brother-in-law's passing, Anthony stepped in to help his sister raise his nieces and nephews. He worked his entire life at Reeves Steel Mill in Dover until his early death in 1966 at the age of 65. (Courtesy of Gloria Marchione Talarico.)

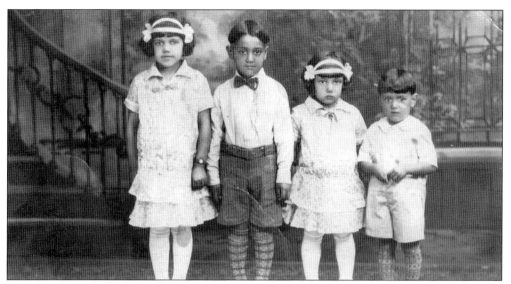

FOUR GALLO SIBLINGS. James and Mary Gallo had six children, four of whom are pictured in this early 1930s photograph. They are, from left to right, Nancy (born in 1923). Alex (born in 1925), Geraldine (born in 1926), and Robert (born in 1928). The family initially lived in Wooster in Wayne County before moving to Navarre in Stark County. (Courtesy of Robert Gallo.)

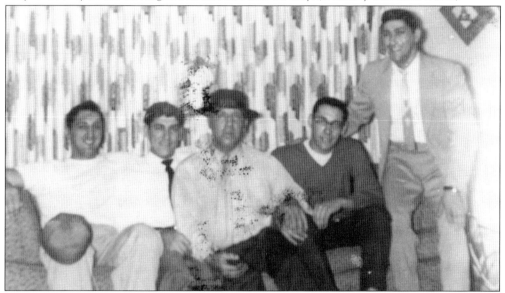

JAMES GALLO SR. WITH SONS. James Gallo Sr. (center) is pictured here with his four sons—from left to right, Alex, Donald, James Jr., and Donald. James Sr. came to the United States in 1913 from the Abruzzi Province in Italy. All four of his sons served their country in the US armed services. In 1953, Alex served with the staff of Vice Adm. John Ballantine, commander of Air Force, US Atlantic Fleet and was part of the invasion at the Normandy beaches in France. Donald served in the Navy, Robert served in the Army in Europe, and James Jr. was in the National Guard. James Jr., who was only nine days old when his mother, Mary, passed away, was raised by foster parents Robert and Margaret Lintner in Navarre. Robert operated a coal and ice delivery business in Navarre. James Jr. graduated from Central Catholic High School in Canton. (Courtesy of Robert Gallo.)

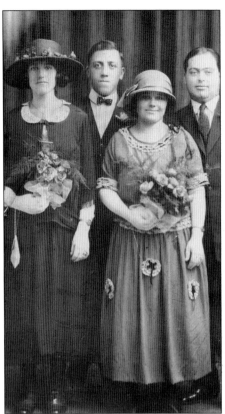

JAMES AND MARY GALLO. Mary and James Gallo (left) are pictured here in Wooster with Margaret and Guy Di Scipio, who, like James, had come from the Italian region of Abruzzi. Tragically, Mary passed away in 1938 when her youngest son was only nine days old. At the time of her death, she had three brothers still living in Italy. (Courtesy of Robert Gallo.)

WILLIAM CAMPOLIETO SEMIPROFESSIONAL FOOTBALL GROUP. In 1938, the Italian American Benevolent Society organized an Italian baseball team. Participating athletes included Ned Pizzino, W. Porrini, F. Sarachene, Min Sarachene, D. Morabito, Joe Morabito, M. Porrini, N. Manack, N. Cincinat, L. Mazzi, B. Sparma, and F. Arnold. In Canton, William Campolieto (back row, third from left) played in a semiprofessional football league. He is pictured here with his teammates in jerseys sponsored by Mergus Restaurant. (Courtesy of William Campolieto.)

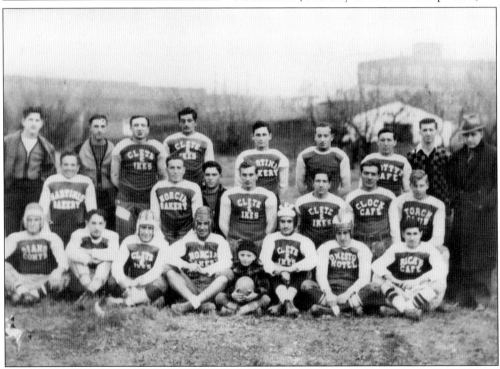

ANNA AMMANNITI, AMELIA DEANGELIS, AND FRANCES STROH. Good friends Anna Ammanniti, Amelia DeAngelis, and Frances Stroh enjoy an apple on a warm, sunny day in Brewster.

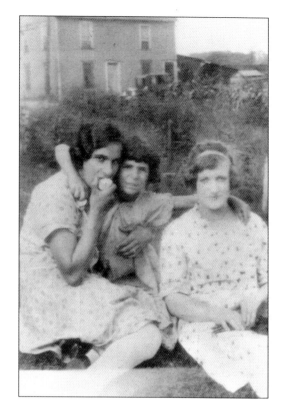

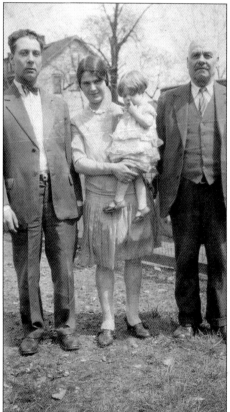

CAPESTRAIN FAMILY. Settimio "Sam," Rose, and Clara Capestrain are pictured here in 1930 with Sam's father, Ferdinando Fiore Capestrain. Their Italian surname was originally Capestrani, but it was changed for (or by) Nazzareno "Albert," the eldest brother and first family member to immigrate to the United States. The name change may have been made by Nazzareno's first employer in Canton. All brothers immigrating thereafter used the new spelling. Sam was born in Goriano Valli, Italy, and lived at home until being conscripted into the Italian army at the age of 18. Shortly after being discharged from the military, he immigrated to the United States. (Courtesy of Bob Capestrain.)

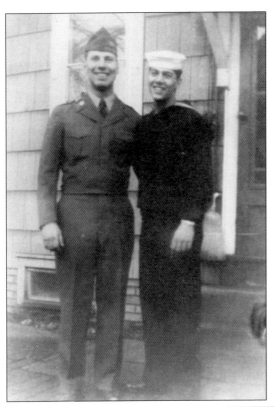

CARL AND ROBERT CAPESTRAIN IN UNIFORM. Brothers Carl (right) and Robert Capestrain served their country in the US armed forces. Carl was in the Navy, and Bob, who volunteered for the draft, was inducted into the Army in 1954. He completed his basic training at Fort Knox, Kentucky, and served in Aschaffenburg, Germany, before being honorably discharged in 1956. (Courtesy of Bob Capestrain.)

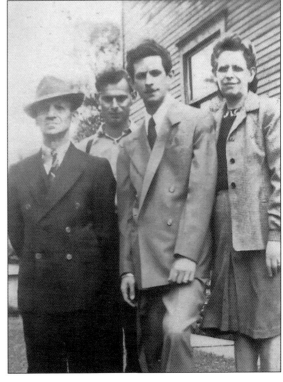

CANDIDO AND CECELIA MARINI. Candido Marini was born in 1887 in Tyrol, Italy (also known as Darzo, Austria, before World War I) and came to the United States in 1899 and worked in the steel mills. His mother and father were born in Hungary. The majority of the population of Tyrol is of Austro-Bavarian heritage and speak German, but approximately a quarter speaks Italian, which included the Marinis. Cecilia was born in 1895 and came to the United States in 1900. Her mother and father were also born in Hungary. Candido and Cecelia raised three children—Frank, born in 1917; Luigi, born in 1921; and Edwin, born in 1925. In this photograph are, from left to right, Candido, Frank, Luigi, and Cecelia. (Courtesy of the Louis Marini Sr. family.)

SABATINO GUIDONE. Sabatino Guidone was born in Tricarico, Italy, in 1885 and came to the United States in 1912. When he first arrived, he lived in Wellsville, Ohio, and owned a restaurant/bar. He was married for 68 years to Esther Ciprian. (Courtesy of Anna Guidone Carozzi.)

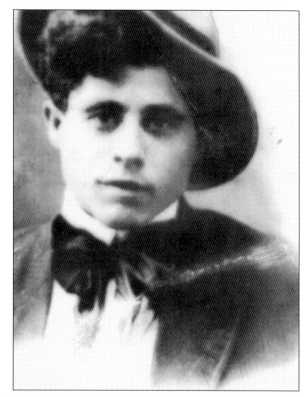

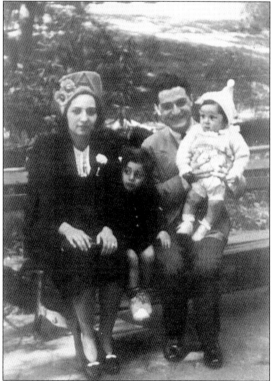

GIUSEPPE AND MARIANNA PILEGGI. In 1939, Giuseppe and Marianna Pileggi moved from Canton to Brooklyn, New York, with their two sons, Joseph (left) and Armando. While living there, they operated an Italian food market, selling olive oil, sausage, and Brazilian coffee. They returned to Canton with their four sons (now including Silvio and Albert) in 1950. (Courtesy of Armando and Frances Pileggi.)

99

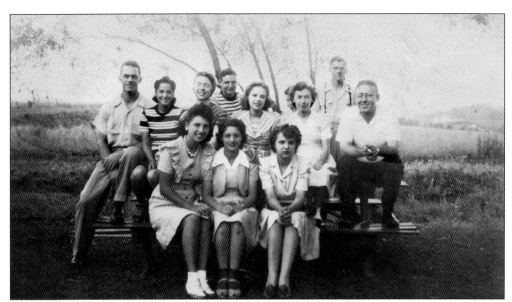

St. Theresian Club Picnic. This photograph was taken at the St. Theresian Club Picnic in 1943 at Lake O' Springs. Pictured, from left to right, are (front row) Eleanor Severini, Gina DeAngelis, and Mary Babich; (second row) Earnest Hummer, Evelyn Hummer, Edith Hummer, Nick Soehnlen, Pauline Babich, Olimpia Gentile, Walter Sessor, and Father Buchholz. (Courtesy of Greg and Sue Monsanty.)

Giuseppe, Marianna, and Vito Pileggi. Giuseppe, pictured here with his wife, Marianna, and father, Vito, was born in Sant'Andrea, Calabria, Italy, in 1913. Vito was born in 1877, also in Calabria, where he had a coach-and-mail service with a 50-mile radius. In 1918, with the outbreak of "La Spagnola" (the Spanish flu epidemic) that killed millions of people, Vito's wife, Caterina, died. Most of his horses perished as well, and around the same time his eldest son, Armando, died in Yugoslavia fighting for the Italian army. With all of this tragedy, Vito made the decision to move to the United States in 1924. (Courtesy of Armando and Frances Pileggi.)

GIUSEPPE PILEGGI WITH BROTHER'S HELMET. Giuseppe Pileggi, pictured with wife Marianna, is shown holding the helmet that his brother Armando wore the day he was killed fighting in Yugoslavia in 1920. (Courtesy of Armando and Frances Pileggi.)

PAUL ANTONELLI PLAYING ACCORDION. The accordion was, and is, a very popular instrument in Italian culture. Here, Paul Antonelli is photographed in 1956 playing the accordion at his annual Halloween party in Canton. (Courtesy of Bob Forchione and Jim Rossi.)

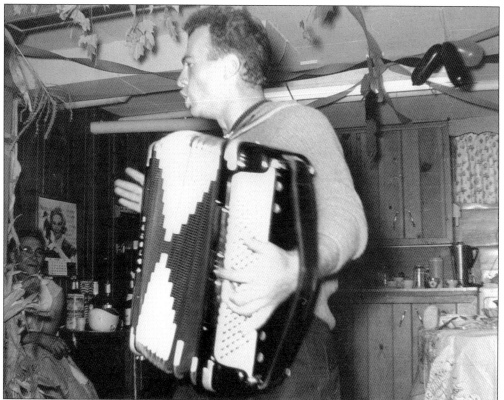

ADAM ROSSI SR. AND ROSE ROSSI. Adam Rossi Sr. and Rose Rossi are pictured in 1937 outside their home in Canton. Both were born in Avellino, Italy, and were married in Italy in 1916. Adam immigrated to the United States with his six brothers and, upon arrival, decided to enter into the funeral business. (Courtesy of Bob Forchione and Jim Rossi.)

BOB FORCHIONE WITH FATHER. Pictured here in 1961 are Bob Forchione (right) and his father, Michael "Prosby" (far left). Bob's mother was Antoinette Rossi, who married Prosby Forchione in 1951 at St. Anthony's in Canton. Sadly, Prosby passed away in 1962 at the young age of 40. Also shown in the photograph are Bob's uncle Dominick Rossi and his cousin Caroline, daughter of Mary Rossi. (Courtesy of Bob Forchione and Jim Rossi.)

LUCIA CHATTERELLI WITH DAUGHTER MARY. Lucia Bastardo Tozzi Chatterelli was born in 1889 in Foggia, Italy. She is pictured here with her daughter, Mary Tozzi. (Courtesy of Matthew and Caroline Chatterelli.)

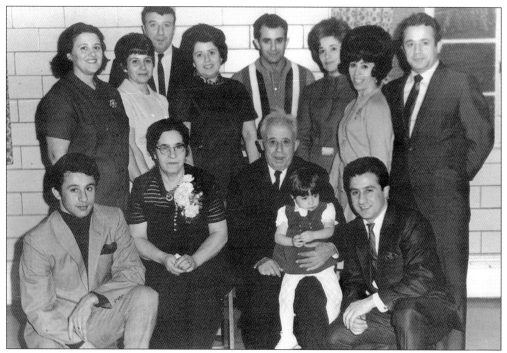

GUIDONE FAMILY PHOTOGRAPH. Sabatino Guidone is pictured here with his wife, Esther Ciprian, and 10 of their 11 children and a granddaughter—Frank, Julius, Mary, Helen, Genevieve, Paul, Lillian, Gene, Anna, Sam, and John. (Courtesy of Anna Guidone Carozzi.)

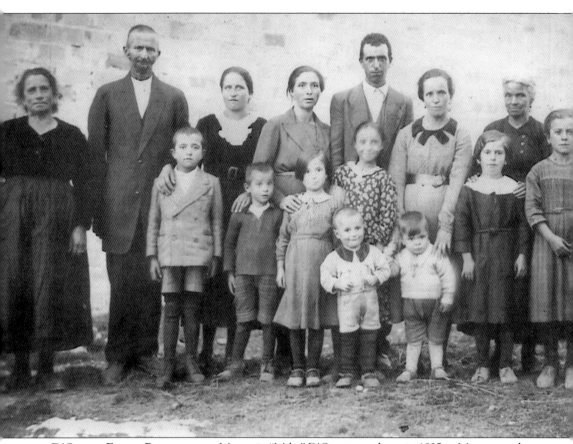

D'Orazio Family Photograph. Marcurio "Mike" D'Orazio was born in 1935 in Montenerodomo, Italy. His was one of many families displaced by the Nazis during World War II, and they were forced to leave their home and find shelter in the nearby woods. In 1954, at the age of 19, Mike and his family boarded the *Omilanda*, an immigration vessel, and came to Ellis Island. He went to work at the Belden Brickyard for 15 months with his father before securing a job at the Timken Company, where he worked for more than 38 years. In this 1939 family photograph taken in Montenerodomo are, from left to right, (first row) Marcurio D'Orazio and Cosmo Rossi; (second row) Anthony D'Orazio, Angelo D'Orazio, Aurelia D'Orazio (grandmother), Maria Melania D'Orazio, Rose Rossi, and Adelaide Rossi; (third row) Filomena Carozzi, Luigi Carozzi, Mary ?, Giovina D'Orazio, Fidel D'Orazio, Carmella Rossi, and Aurelia D'Orazio (granddaughter). (Courtesy of Marcurio "Mike" and Mary Ann Bernard D'Orazio.)

CATHERINE MAGGISANO/MARGAZANO AND JOHN ZIMBELLO. Catherine Dominelli Maggisano married John Zimbello in 1917. Catherine was born in Italy in 1892 and came to the United States in 1912, and John, the son of Jose and Rosa Betti Zimbello, was born in Altamura, Italy, in 1889 and came to the United States in 1914. John was a night watchman, and he and Catherine lived in Massillon and had five children—Joseph, Elizabeth, Theresa, Irene, and Eugene. (Courtesy of Edna Kemerer.)

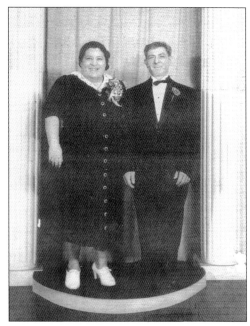

LOUIS MARINI SR. WITH CHILDREN. This 1960 image taken in Alliance is of Louis Marini Sr. with his three children—from left to right, Ken, Susan and Louis Jr. Louis Jr. grew up in Beach City, Ohio, and graduated from Fairless High School in Navarre. He is a well-known saxophonist, arranger, and composer and one of the original members of the Saturday Night Live Band and Blues Brothers Band. He has played with some of the industry's most prominent bands and musicians, including the Rolling Stones, Aerosmith, Billy Preston, Frank Zappa, Blood, Sweat and Tears, Stevie Wonder, Diana Ross, and Tony Bennett. (Courtesy of the Louis Marini Sr. family.)

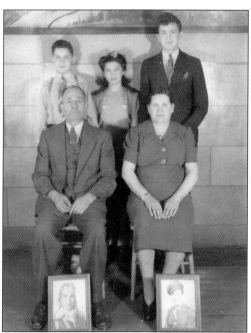

BRUNO AND MARY CODISPOTI WITH FAMILY. Bruno Codispoti came to the United States in 1914 from Sant'Andrea, Italy, and became a citizen in 1943. His wife, Anna Maria Lijoi (Lioi) immigrated in 1921 and gained citizenship in 1947. They are pictured here with son Isidore (back left), daughter Elizabeth "Lizzie," and son Andyvo. Isidore went on to become a dentist; Lizzie, unfortunately, died at an early age of leukemia; and Andyvo served his country in the Army during World War II. On the floor are photographs of another son and a nephew, both named Vince. (Courtesy of Andy and Leota Codispoti.)

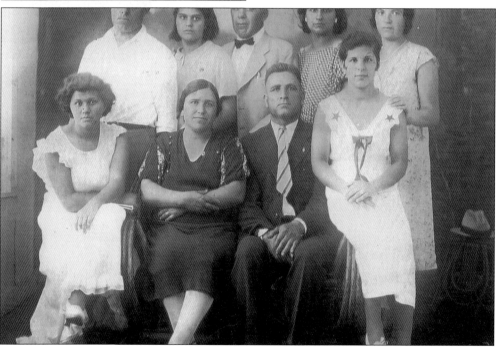

BREWSTER FRIENDSHIPS. Domenico Silvestri was born in Savelli, Italy, in 1901 to Angelo and Angela Poggi Silvestri. He married Brewster-born Lena Leonetti, daughter of Antonio and Santo Crisciotti Leonetti, in December 1930, and the pair settled in Brewster. Pictured here with the Silvestris are, from left to right, (front row) Benedetta Musacchia, Michelina Frustaci, Fortunato Frustaci, and Amelia DeAngelis; (second row) Domenico Silvestri, Angeline Musacchia, Cesare Scarpellini, Anna Ammanniti, and Lena Leonetti. Domenico and Fortunato both worked on the railroad.

SETTIMIO CAPESTRAIN. Settimio Capestrani (aka Samuel Harry Capestrain) was born in Goriano Valli, Italy, in 1900 to Ferdinando Fiore Capestrani and Sara Santilli. He came to the United States in 1925 and worked at Republic Steel with his brother. His wife, Rosa Lucia Ramuno, was born in 1910 in Dunbar, Pennsylvania, and the couple belonged to the Sons of Italy in America, the Dante Alighieri Benefit Society, the Amerital Benefit Society, the Roma Circle Club, the Italian Women's Club, the Alliance Christopher Columbus Club, and the Italian Central Committee. (Courtesy of Bob Capestrain.)

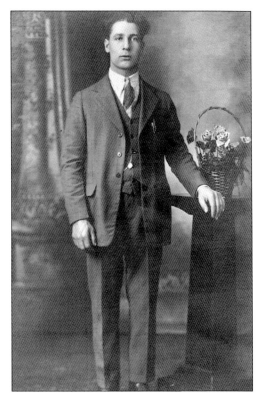

JOSEPHINE MERCORELLI AT EIGHT YEARS OLD. Josephine Mercorelli, daughter of Samuel and Mary Mercorelli, is pictured in downtown Canton at eight years old. Sam was born in the United States in 1905, but his parents moved back to Italy when he was one year old. He returned to the United States at the age of 16. (Courtesy of Bob Capestrain.)

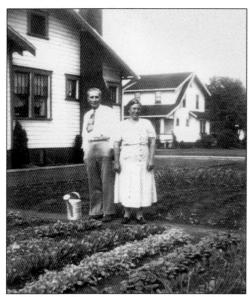

LOUIS AND PASQUALINA MONSANTY GARDEN. Like most Italians, Louis and Pasqualina Monsanty had a beautiful garden that was a great source of pride. They are pictured here in front of it. (Courtesy of Greg and Sue Monsanty.)

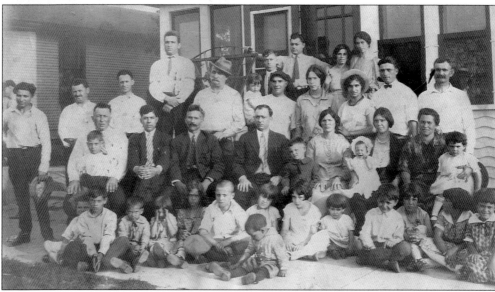

GATHERING OF BREWSTER ITALIANS. The Brewster Italians pictured here are, from left to right, (first row) Mary Mazzaferri, James Musacchia, Nancy Ferrelli, Antoinette DeAngelis, Jenny Ferrelli, Gidio Ferrelli, Tony Ferrelli (in front), Ursula Wilyat, Madeline Wilyat, Margaret Wilyat, James Wilyat, Amelia DeAngelis, Benedetta Musacchia, and Angeline Musacchia; (second row) Cesare Scarpellini (holding Patsy Ferrelli), Joseph Manello, Dan Ferrelli (Frailly), Bruno Codispoti, Vincent Codispoti, Maria Codispoti, Maria Ferrelli (holding Nellie), and Ursuline Musacchia (holding Josephine Musacchia); (third row) John Mazzaferri, Pete DeAngelis, Giovanni Bruzzetti, Fortunato Frustaci, Angelo Ammanniti, Gina DeAngelis (child), Julio Ammanniti, Helen Moder, Ann Ammanniti (with hat), Otto Diotallevi, and Castenze Musacchia; (fourth row) unidentified, Alessandro Peroni, Fern Cavicchia, and Anna DeAngelis. James Vigilanti was born in 1864 in Abruzzi, Italy. When he came to the United States in 1893, the family name was changed to Wilyat. Anna Severini was born in Italy in 1905 and came to the United States in 1910. (Courtesy of Antoinette DeAngelis.)

COSENTINO FAMILY. Frank and Riantonia Cosentino and their children were born in Sant'Andrea, Italy, came to the United States in 1937 on the immigration vessel SS *Saturnia*, and settled in Canton. Frank worked at Republic Steel. Son Joseph was 17 years old when he arrived in Canton. Because he did not speak English when he arrived from Italy, he was placed in first grade. However, he was a quick learner. By the time Joseph turned 24 years old, in 1944, he had graduated from Mount Union College and went on to become an educator and administrator in the Canton school district. Seen here in the early 1940s are, from left to right, (front row) Riantonia and Frank; (back row) Victoria and Giuseppe "Joseph." (Courtesy of Frank Cosentino.)

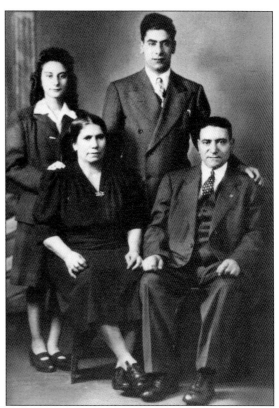

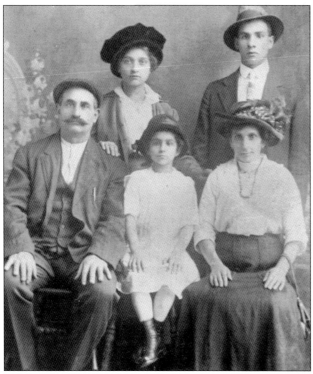

AMMANNITI FAMILY. Angelo Ammanniti was born in 1870 in Capitignano, Italy, and came to the United States in 1906. Mariangela Ammanniti was born in 1865 and immigrated to the United States in 1907. They are pictured here with their three children. Son Giulio was born in 1898 in Italy and came to the United States with his father in 1906. He returned to Italy to marry Argia Palidori in 1926 before permanently relocating to the United States in 1927. Daughter Filomena (standing) came to the United States with her family but then returned to Italy to marry Francesco Pelosi, to whom her hand had been promised. Daughter Anna was born in Ohio in 1910 and would eventually marry Ottavio Diotallevi. (Courtesy of Karen Diotale Kelly.)

FRANCES CODISPOTI IN NAPLES, ITALY. Frances Codispoti was born in Naples, Italy, and came to the United States in 1959, where she married Armando Pileggi. Here, she is pictured in her hometown in 1958. (Courtesy of Armando Pileggi.)

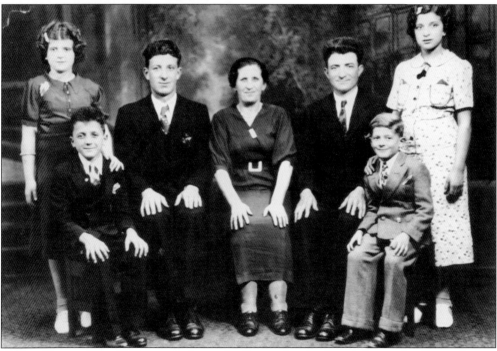

FARINA FAMILY. This 1930s image shows the Farina family: from left to right, Susan, James, Joseph, Restituta, Frank Sr., Frank Jr., and Mary. Frank Sr., Restituta, and eldest son Joseph were all born in Sora, Italy, and came to the United States in 1923. Frank Sr. initially worked in the local brickyard and then went to work for the Timken Company in Canton. Daughter Mary Farina married Joseph Cosentino in 1945 in Canton and raised three children, Frank, Rita, and Theresa. (Courtesy of Frank Cosentino.)

PILEGGI WITH SONS. Giuseppe Pileggi (far right) is pictured here with his three sons—from left to right, Joseph, Armando, and Silvio. (Courtesy of Armando and Frances Pileggi.)

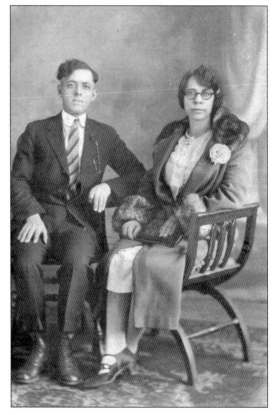

FRANK PARIS AND DONATA CIPRIANI. Frank and Donata Cipriani Paris were married in Ohio and had four children. Celia "Etsy," who married John Mercer; Robert "Otty"; Mary; and Bernard. Frank was born in Rome, in 1887 and lived in a children's home until being adopted in 1903. In Italy, his name had been Leonard Trombe, but when he came to the United States in 1906, it was Frank Leonard Paris. He worked for 50 years at the Norfolk & Western Railroad and became a naturalized citizen. Frank took great pride in gardening, considering it a privilege and a responsibility to his family and to his adopted country. Frank and Donata lived in Navarre and were members of St. Clement Catholic Church. (Courtesy of the John and Celia Paris Mercer family.)

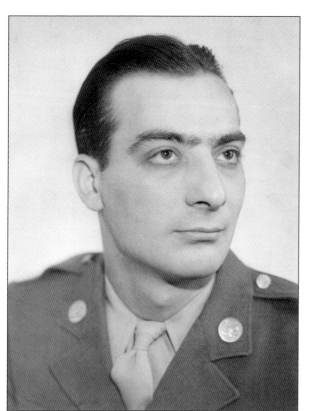

WILLIAM CAMPOLIETO IN UNIFORM. William Campolieto was one of the first young men drafted in 1941 during World War II and served four and a half years in the US Army. He is pictured here in his uniform. (Courtesy of William Campolieto.)

ANTHONY TALARICO WITH BUSINESSMEN. Anthony Talarico Sr. (far right) is pictured with colleagues from the Hercules Company in 1950. When Talarico applied for employment, Hercules was not hiring foreigners, so he applied under the name "Anthony Perry" and received a job offer. Anthony and his wife, Mildred, had two sons, Francis "Frank" and Anthony Jr. Shortly after Anthony Jr.'s birth, Mildred left the boys in her husband's care and disappeared. Fortunately, Anthony's sister Mae helped her brother raise his two sons. (Courtesy of Gloria Marchione Talarico.)

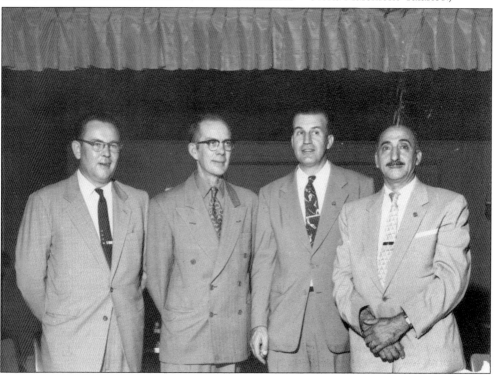

CLORINDA "LENA" DEANGELIS AND ALBERT CORSI. Albert Corsey (Corsi) was born in Italy in 1901 and came to the United States in 1905 when he was four years old. Albert's father was Olindo, and he had two sisters, Mary and Flora. Clorinda DeAngelis was born in Amatrice, Italy, in 1913 and came to the United States in 1915. Her father, Antonio, waited until she was 16 years old to allow her to marry Albert. However, after her marriage, she obtained a copy of her birth certificate and discovered that she was only 15 years old at the time of her wedding. The couple lived close to St. Anthony's Catholic Church in Canton their entire married lives. (Courtesy of Marj Corsi.)

BREWSTER FRIENDS IN THEIR EASTER FINEST. Pictured in Brewster from left to right, Diana Diotallevi, Gina DeAngelis, Maria Cavicchia, and Frances Stroh are in their Easter outfits. (Courtesy of Antoinette DeAngelis.)

113

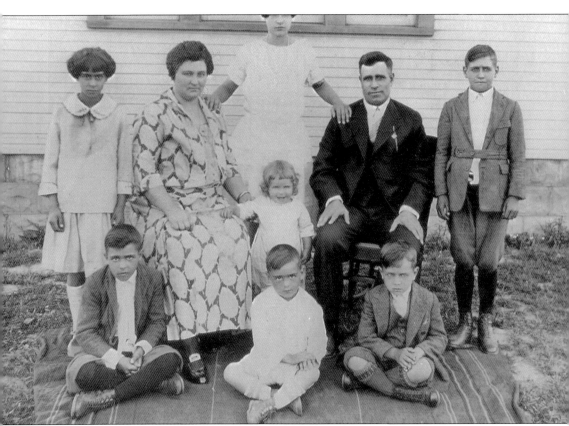

DiLoreto Family Photograph in Brewster. Giuseppe "Papa Joe" DiLoreto was born in Capitignano, Italy, and came to the United States in 1906. He lived for a year with Italian friends who had settled in Massillon and obtained employment as a stationary fireman for the Wheeling & Lake Erie Railroad. He returned to Italy in 1911 and married the former Marguerita DeAngaris in 1912 before he came back to the United States in 1913. In 1914, he sent for his wife and their baby daughter, Jeannette. This photograph, taken in 1931 in front of their home, includes, from left to right, (first row) Tony, Alfred, who died at a young age in 1937, and Robert; (second row) Eva, Marguerite, with Henry (youngest), Jeannette, Giuseppe, and Arturo "Peo." Papa Joe was known around Brewster for making his own bagpipes and playing them as often as possible. He brought back the wood from Italy, and the goatskin was given to him by a Brewster friend. He also played the concertina. (Courtesy of Lauretta Porrini Gerber and Gloria Waller Reidenbach.)

ANTHONY AND OLIVER MAZZAFERRI IN UNIFORM. Brothers Anthony (left) and Oliver Mazzaferri both served their country during World War II. Anthony served in the Army Air Corps, and Oliver was in the Army. During World War I, Italian immigrants had been able to stay in the United States until Italy aligned itself with the Allies. At that time, they were required to serve in the Italian army, but were guaranteed return passage to the United States after the war. Anthony and Oliver's father, Giovanni, came to the United States at the age of 18 and returned to Italy during World War I to serve in the Italian army. (Courtesy of Bonnie Mazzaferri Dourm.)

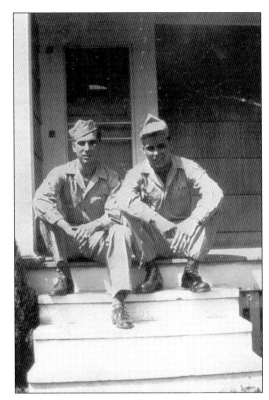

DOMINIC AND JOSEPHINE PICIACCHIO. Dominic and Josephine Piciacchio were born in Capitignano, Italy, and came to the United States in 1909. They lived in Brewster, and Dominic worked on the railroad. His paychecks were made out to "Pisock" because his employer could not spell his Italian name correctly. Dominic and Josephine had two sons, Emilio and Pietro. (Courtesy of Sue Piciacchio.)

MAZZAFERRI SISTERS AND ANNA DEANGELIS. Lucia Ventura Mazzaferri (right) and her sister Josephine (left) were born in Capitignano, Italy, where their father was a carpenter. They lost their mother at a very young age, and when their father remarried several years later, they went to live in Rome. Josephine preferred living in Capitignano, however, and returned to her home. Lucia spent her teen years living with a diplomatic family as a companion. While there, she learned housekeeping and artistic skills, had many cultural experiences, and was treated as a member of the family. (Courtesy of Bonnie Mazzaferri Dourm.)

CATHERINE MAGGISANO WITH CHILDREN. Catherine Dominelli (aka Daneanelle) and her husband Nick Maggisano (son of Dominick and Maria Labella Nieste Maggisano) moved to the United States in 1912 with their two children. There, they had three more children. Nick worked on the railroad and was tragically killed on the job in 1916 by an oncoming passenger train. In 1917, Catherine married John Zimbello, and they raised five children. This photograph shows Catherine with five of her ten children—Nick, Mary, Isabelle, Frank, and Pauline. (Courtesy of Edna Kemerer.)

JAMES AND CARMEL ANGELLO.
James Angello is pictured
here with his wife, Carmel
D'Aurelio. James's parents,
Gaspare and Francis, came
from Palermo, Italy, to Ohio
in 1910. Their original name,
Augello, changed somewhere
along the way to Angello.
James and Carmel had six
children—Barb, twins Judy and
James, Joe, Marcia, and Conni.
(Courtesy of Jim Angello.)

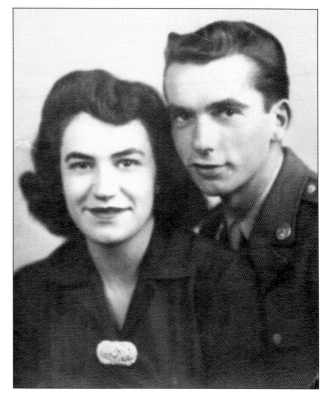

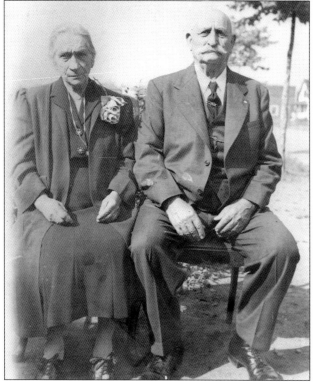

**AMMANNITI 50TH WEDDING
ANNIVERSARY.** In October
1944, Angelo and Mariangela
Ammanniti celebrated their 50th
wedding anniversary with a Mass
of Thanksgiving at St. Therese
Catholic Church in Brewster.
They were married in Italy,
but by 1944 they had resided
in Brewster for 34 years. Their
anniversary party was held in St.
Therese's parish hall. (Courtesy
of Karen Diotale Kelly.)

GASPARE AND FRANCIS ANGELLO. Gaspare, born in 1876 in Palermo, Italy, came to the United States in 1903. Frances Mula, born in 1881, came to the United States in 1905 with son Ciro and daughter Elisa "Lizzie." They originally landed in Belmont County, where Gaspare worked in the coal mines. The couple had seven more children—Pete, Mary, Joseph, Jane, Josephine, Gaspare, and James. (Courtesy of Jim Angello.)

MARCHIONE FAMILY AT EASTER. Pictured one Easter in Tuscarawas County are, from left to right, (first row) Stan Massarelli, Ruby Marchione Massarelli, Joanne, Gloria, and Carmela Marchione, Anthony Tristano, and Pauline Marchione; (second row) Anthony and Dean Marchione. (Courtesy of Gloria Marchione Talarico.)

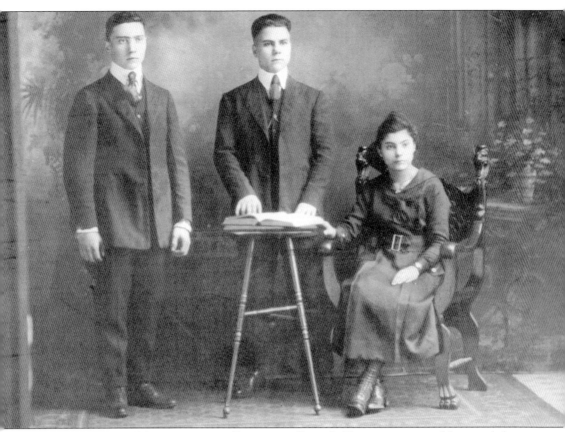

CARMELA TRISTANO MARCHIONE WITH BROTHERS. Carmela Tristano is pictured here with her brothers Ben (left) and Anthony. Their parents were Pasquale and Cherubina Amicone Tristano, and they were born in Tuscarawas County. (Courtesy of Gloria Marchione Talarico.)

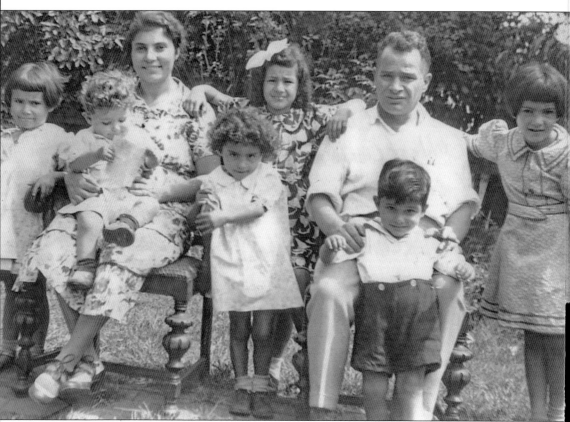

Marchione Family in 1939. Carmela and Archangelo Marchione are photographed here with their six children—from left to right, Joanne, Dean, Gloria, Pauline, Anthony, and Ruby. Archangelo, born in Vastogirardi, Italy, in the Abruzzi Province, was slightly crippled due to a birth injury. In Italy, in order to compensate for a special need, children were taught a special skill, and Archangelo was taught the trade of a shoemaker. Because of his special training, he was able to immigrate to the United States under the sponsorship of another immigrant shoemaker already established there. (Courtesy of Gloria Marchione Talarico.)

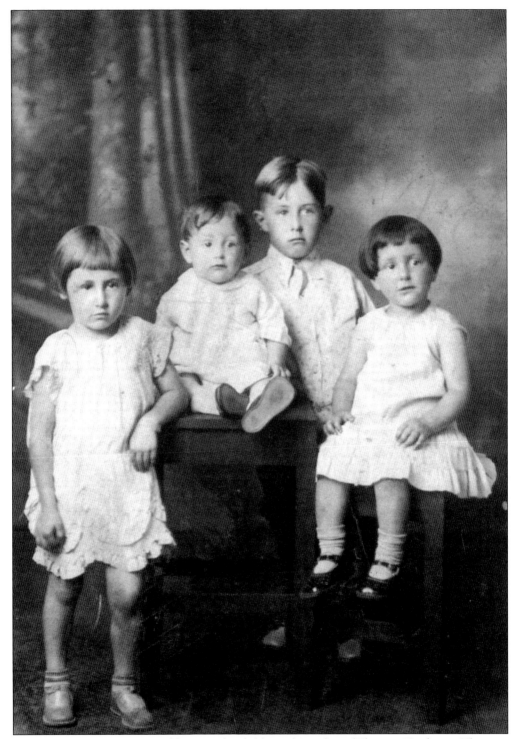

FORCHIONE CHILDREN. Pictured here are the children of Angelo and Florence Forchione. They are, from left to right, Mary, Frank, John, and Vincenza "Nancy." (Courtesy of the Frank Forchione Sr. family.)

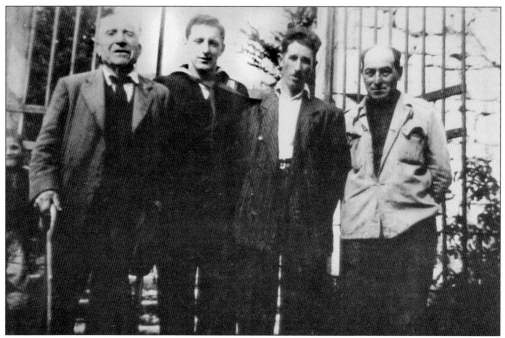

FRANK FORCHIONE IN FAETO, ITALY. This photograph was taken in 1950 in Faeto, Italy. The three younger gentlemen are, from left to right, brothers Frank, Leonardo, and Joseph Forchione. Frank served his country in the US armed forces and visited Faeto, Italy, his family's hometown, while serving. (Courtesy of the Frank Forchione Sr. family.)

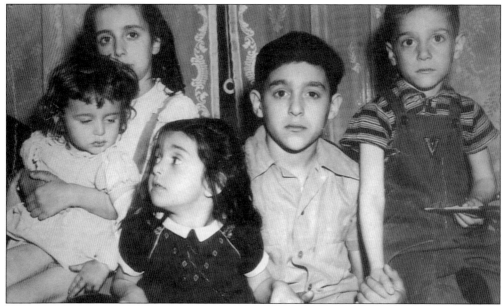

CAPUANO SIBLINGS. In April, 1947 the Capuano family home caught fire and claimed the lives of Margaret Capuano and the two eldest daughters—Betty, 17, and Lena, 14. This photograph was taken the morning after the fire in which son Luigi Jr., 13, (fourth from left) helped rescue his younger siblings—from left to right, Theresa, 2, Yvonne, 9, Loretta, 4, and Ralph, 5, from the flames. (Courtesy of the Luigi and Lucia Olivieri Capuano family.)

ANNA GUIDONE ON BICYCLE. Anna Guidone is photographed here on her bicycle in Wellsville, Ohio. Her mother, Esther, not only made this outfit but made most of Anna's and her sisters' clothes. (Courtesy of Anna Guidone Carozzi.)

CARMELLA AND FRANK CAROZZI. Carmella Carozzi is pictured here with her 15-year-old son Frank at the Belden Grill, which she and husband Nick owned and operated until the 1980s. Carmella married Nick Carozzi in Italy and then came to the United States in 1933, where Frank was born. (Courtesy of Anna Guidone Carozzi.)

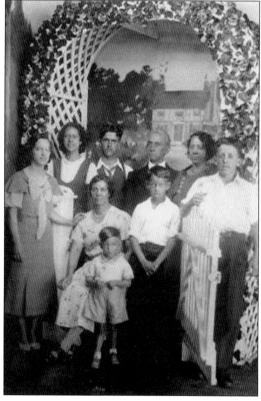

FERRELLI (FRAILLY) FAMILY. Pictured here in Brewster is the Ferrelli (aka Frailly) family. They are, from left to right, (back row) Rose Frailly, Jenny Frailly, Gidio Frailly, unidentified, Donata Paris, and Robert Paris; (second row) Mary Frailly and Benny Frailly; (first row) Patsy Frailly. (Courtesy of the John and Celia Paris Mercer family.)

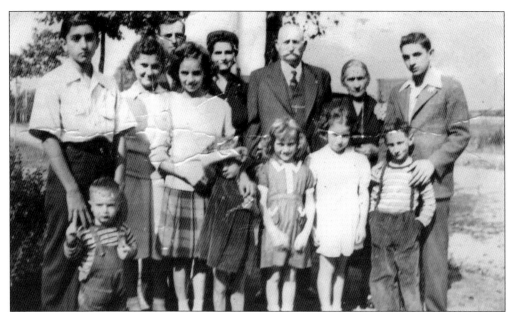

DIOTALLEVI FAMILY. Angelo and Mariangela Ammanniti are pictured here with their daughter Anna; her husband, Ottavio Diotallevi; and nine of Ottavio and Anna's ten children. (Courtesy of the Olindo and Justina Ventura Pelosi family.)

MARCURIO D'ORAZIO IN UNIFORM. Shortly after arriving in the United States in 1954, Marcurio D'Orazio joined the US Army to serve his adopted country. At the time, however, he could not yet read and write English proficiently. When he was presented with a written exam as part of his enlistment, he told the instructor that he could not read it in English and asked to take it in Italian. The instructor informed him that he could not do that, so Marcurio was honorably discharged. (Courtesy of Marcurio "Mike" and Mary Ann Bernard D'Orazio.)

Silvio DeAngelis, Silvio Diotallevi, and Friends. This late-1940s photograph, taken in Brewster, shows, from left to right, Nick Diotallevi, Silvio Diotallevi, unidentified, Ottavio Diotallevi, and Silvio DeAngelis. (Courtesy of Greg and Sue Monsanty.)

ANNA GUIDONE IN UNIFORM. Anna Guidone, who served her country in the US Marine Corps, is pictured here in uniform in 1958. (Courtesy of Anna Guidone Carozzi.)

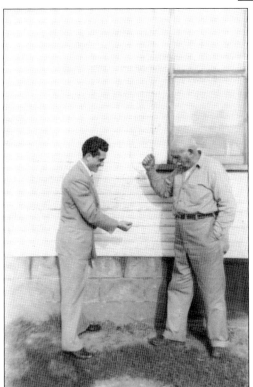

OLINDO PELOSI WITH MATERNAL GRANDFATHER. Seen here playing the Italian game morra are Olindo Pelosi and his maternal grandfather, Angelo Ammanniti. Morra is a hand game that dates back thousands of years. While there are many variations of morra, most versions can be played with two, three, or more players. In the most popular version, all players throw out a single hand, each showing zero to five fingers and call out loud their guess at what the sum of all fingers shown will be. If one player guesses the sum, the player earns one point. The first player to reach three points wins the game. (Courtesy of the Olindo and Justina Ventura Pelosi family.)

DISCOVER THOUSANDS OF LOCAL HISTORY BOOKS FEATURING MILLIONS OF VINTAGE IMAGES

Arcadia Publishing, the leading local history publisher in the United States, is committed to making history accessible and meaningful through publishing books that celebrate and preserve the heritage of America's people and places.

Find more books like this at
www.arcadiapublishing.com

Search for your hometown history, your old stomping grounds, and even your favorite sports team.

Consistent with our mission to preserve history on a local level, this book was printed in South Carolina on American-made paper and manufactured entirely in the United States. Products carrying the accredited Forest Stewardship Council (FSC) label are printed on 100 percent FSC-certified paper.

MADE IN THE